THE HARDEST THING TO SEE is what is in front of your eyes. —JOHANN WOLFGANG VON GOETHE WHAT DOES NOT EXIST looks so handsome. — RUMI ART does not come and lie in the beds we make for it. it slips away as soon as its name is uttered: it likes

to preserve its incognito. its best moments are when it forgets its very name. —JEAN DUBUFFET VISION IS THE ART of seeing things invisible. - JONATHAN SWIFT WE HAVE NO ART, we do everything as well as possible. - BALINESE PROVERB

INVISIBLE ART

INVISIBLE ART

COMPILED BY

THE ART BROTHERS

DARLING & COMPANY
MCMXCIX

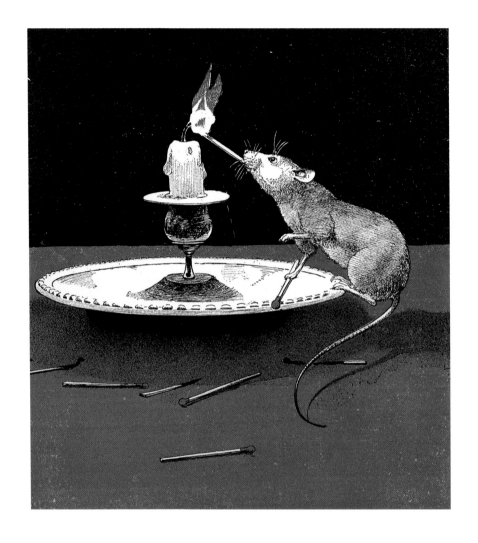

Design by Blue Lantern Studio.

ISBN 1-883211-16-6

Darling & Company

Post Office Box 4399
Seattle Washington 98104

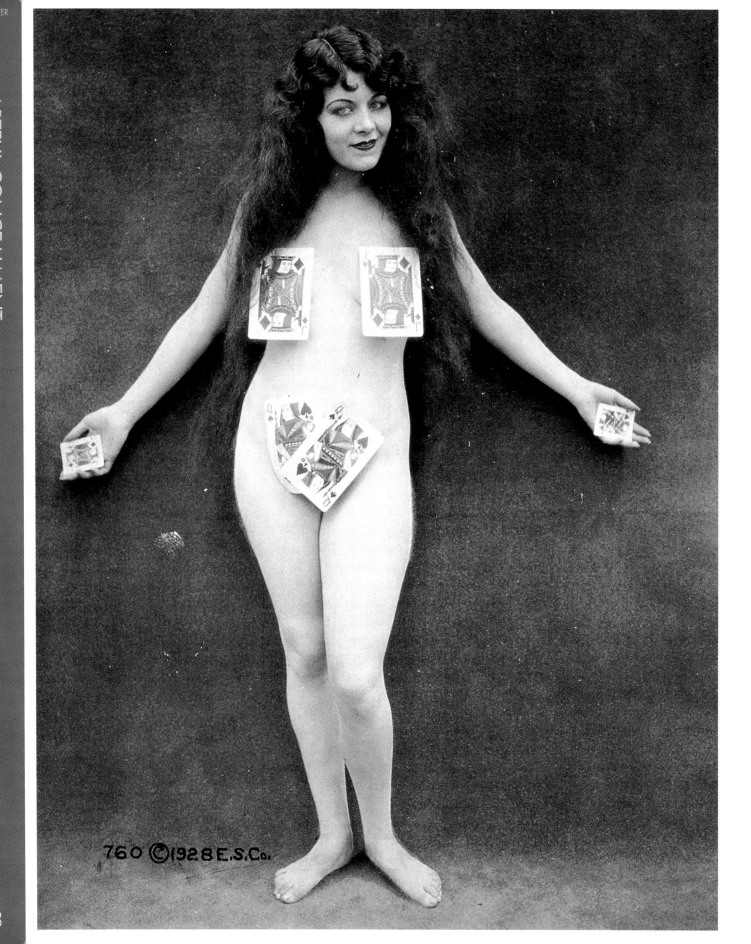

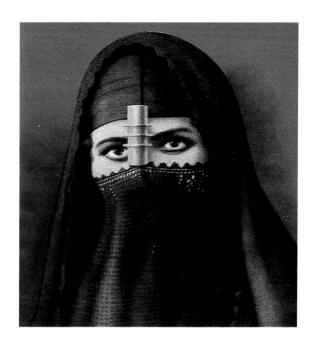

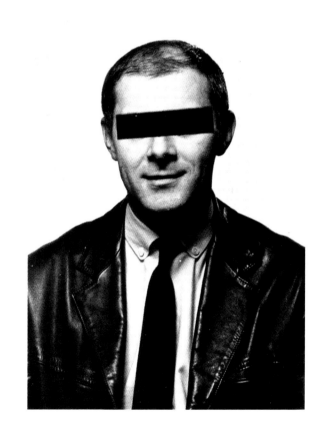

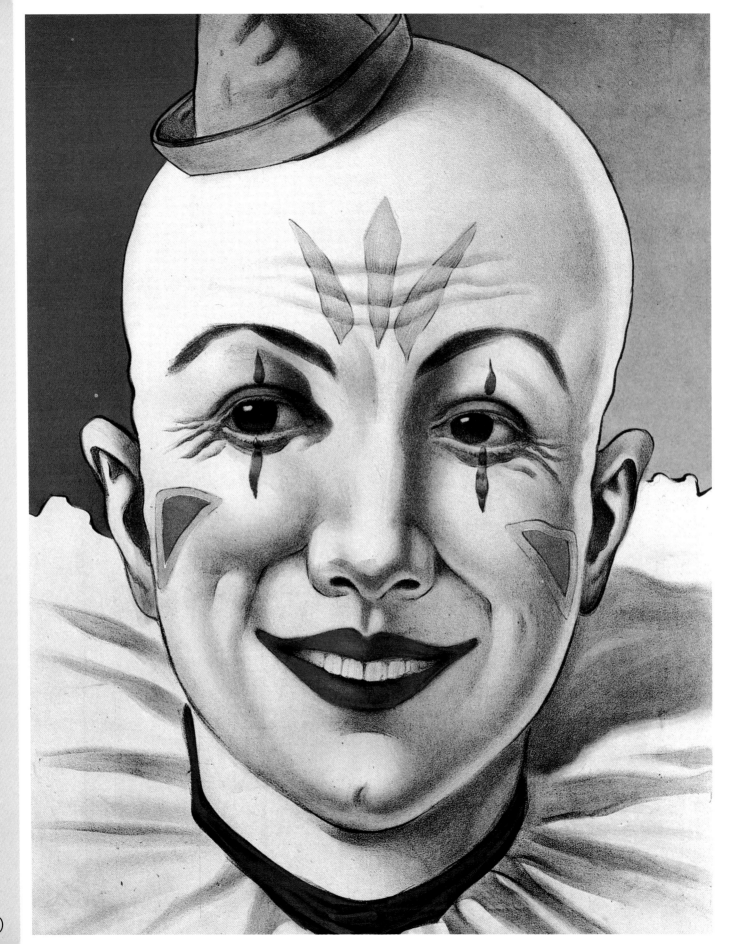

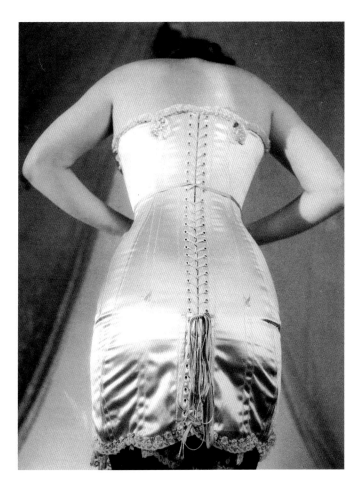

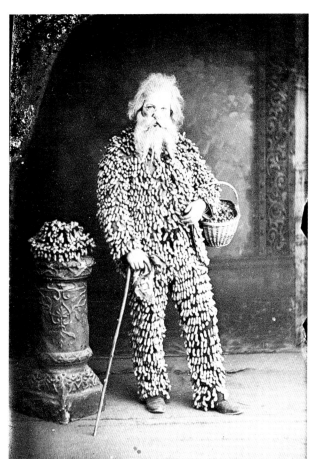

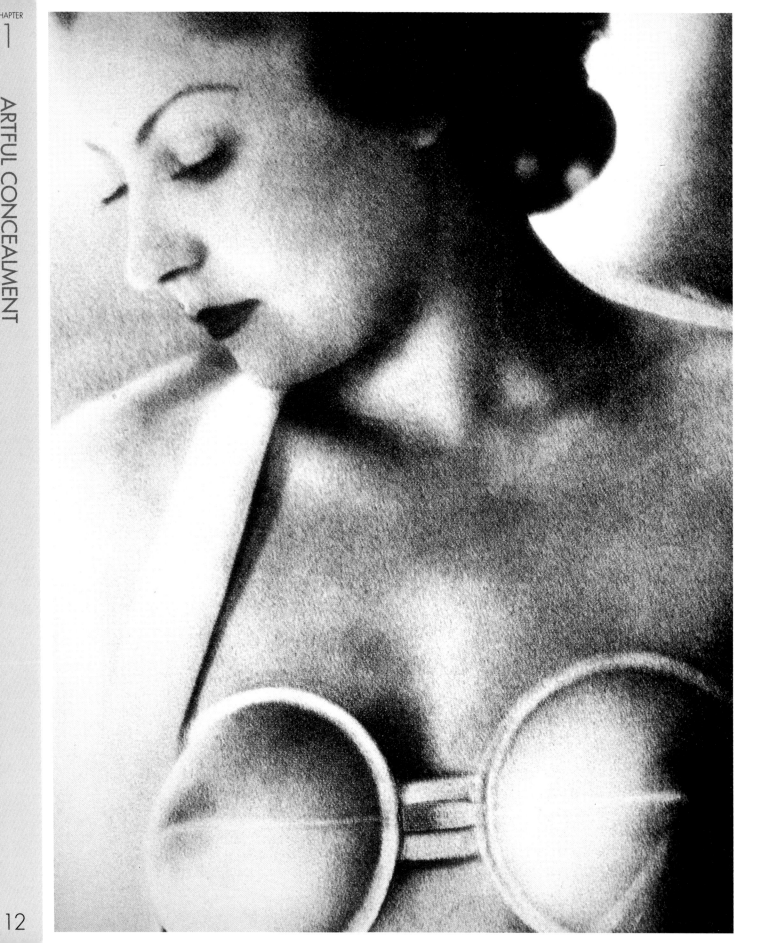

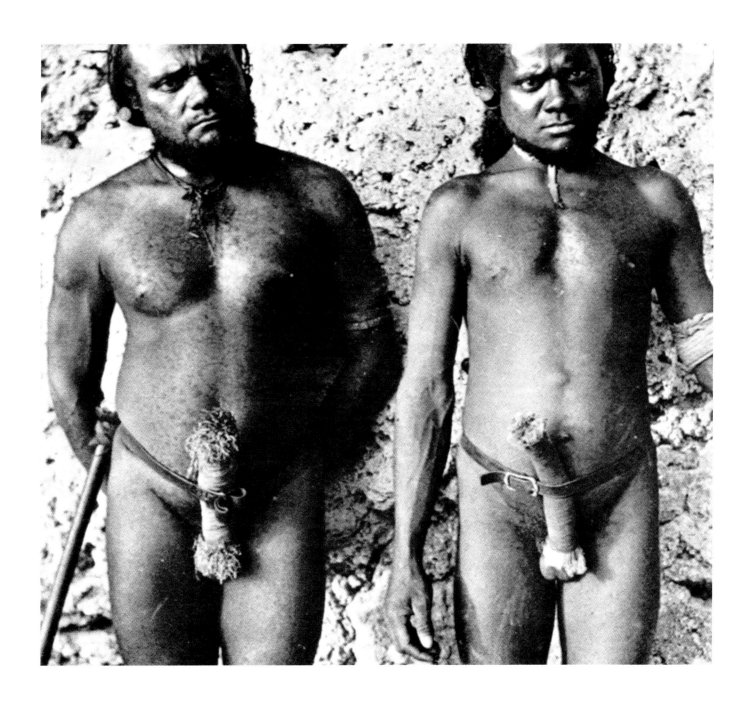

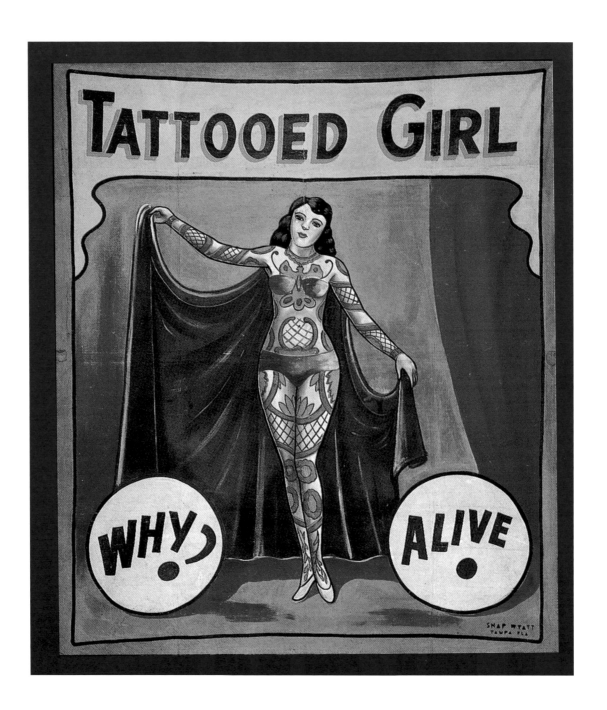

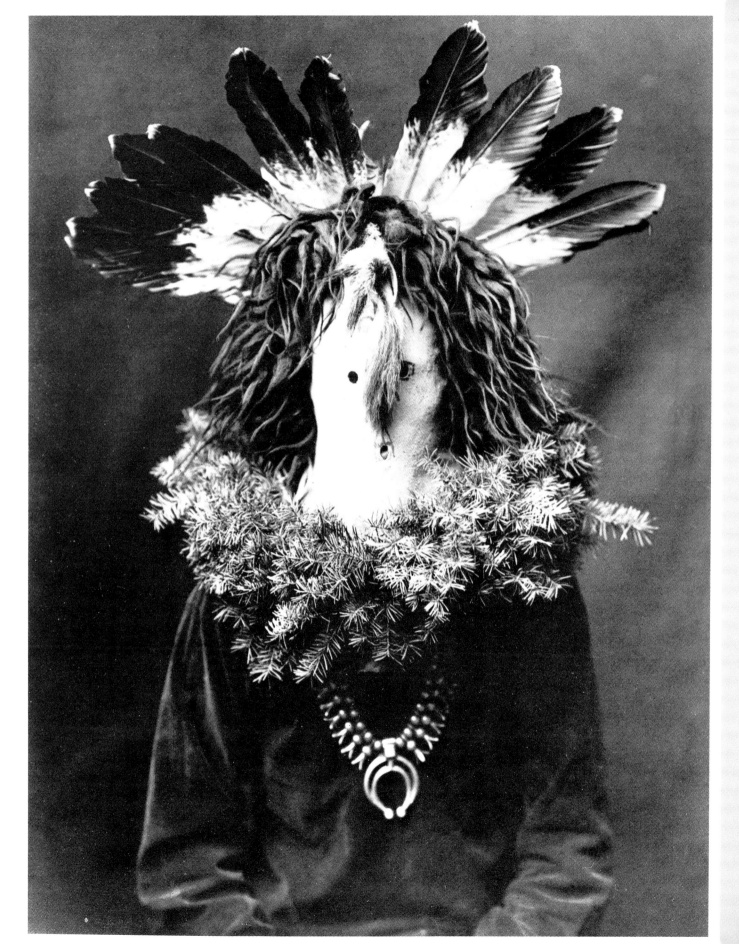

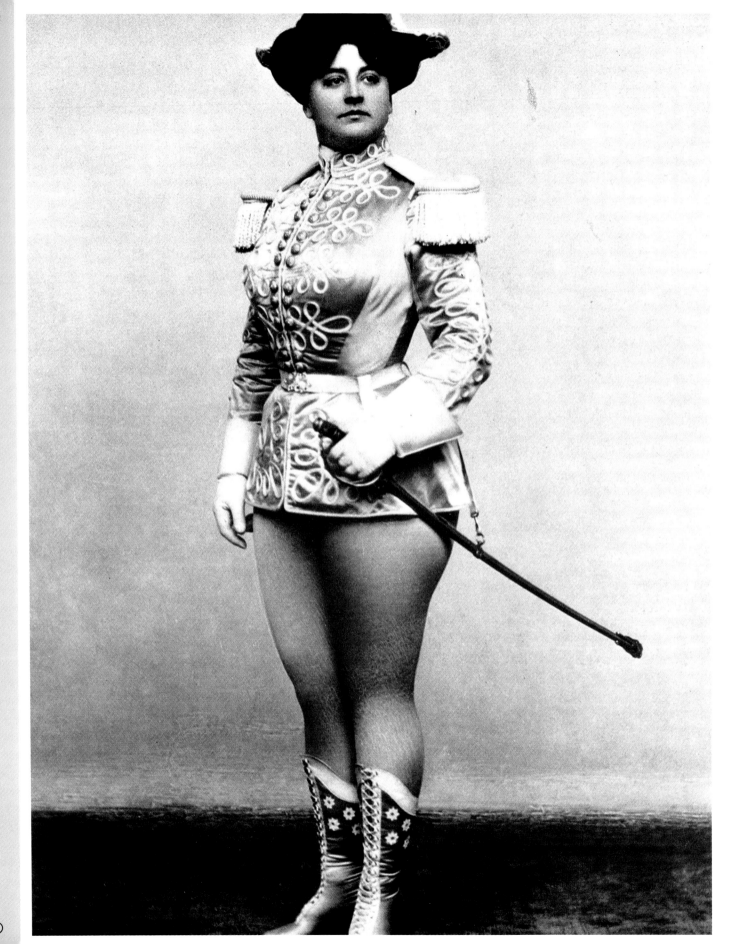

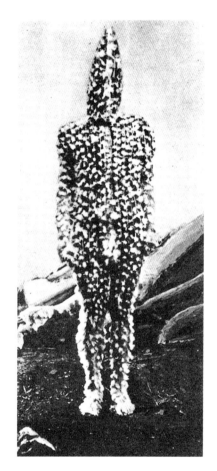 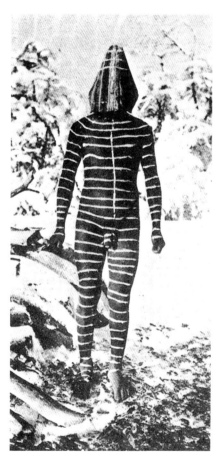

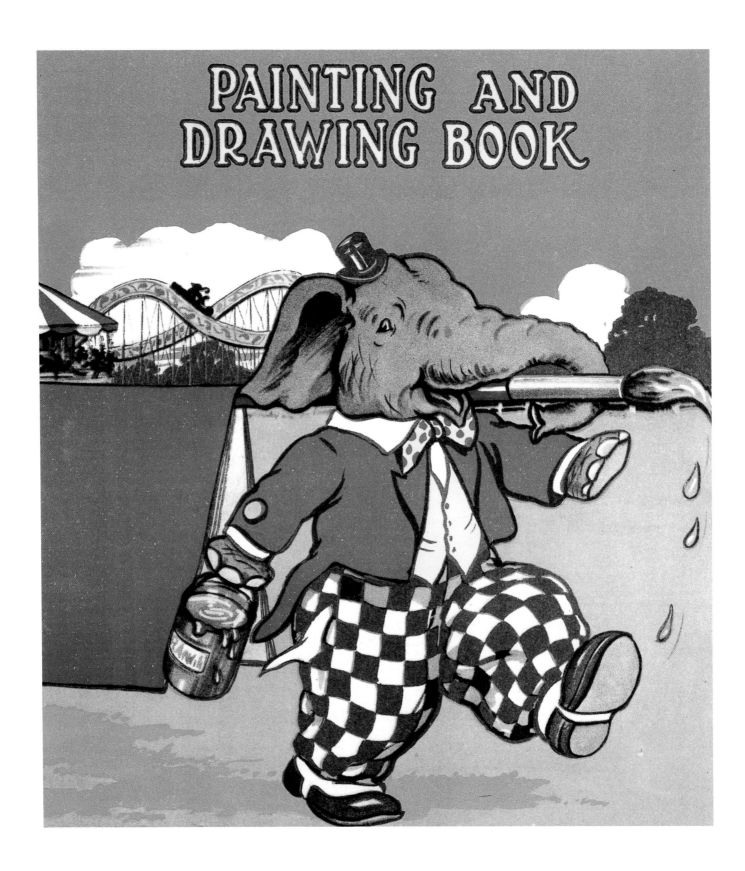

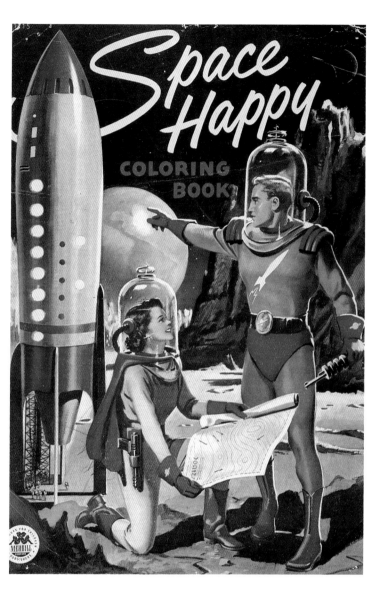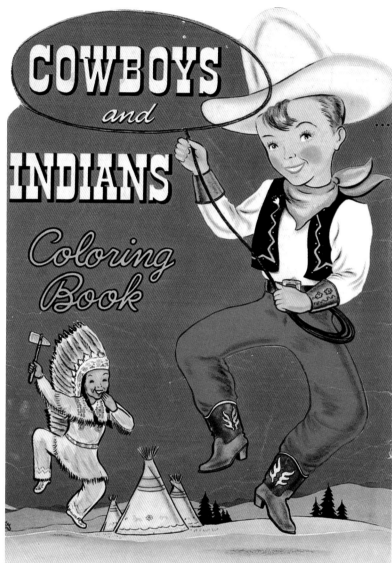

Children's painting and coloring books have been a part of the publishing world for over a hundred years.

The earliest American coloring book appears to have been produced by McLoughlin Brothers of New York City in 1885. This inside of the *The Little Folks Painting Book* states: "The need of a cheap, and at the same time interesting and sensible Book of Pictures for Children, to try their skill at painting, has long been felt. We have thought it best to make the book without reading matter in order to give a greater number of pictures. Anything that will keep the children still, has always been a desideratum with parents; and there is probably nothing which is so universally popular with the little ones, as painting with their own Paint-Boxes, as their Spelling-Books and Primers too often show."

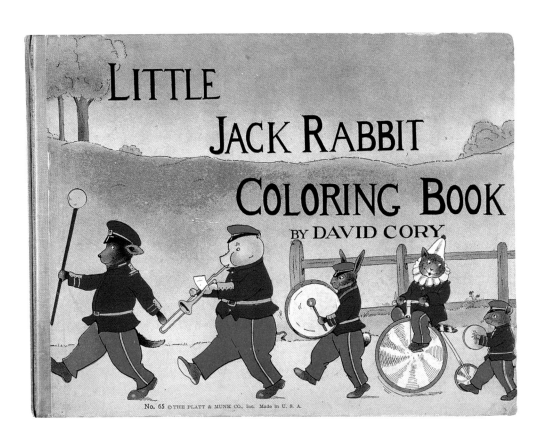

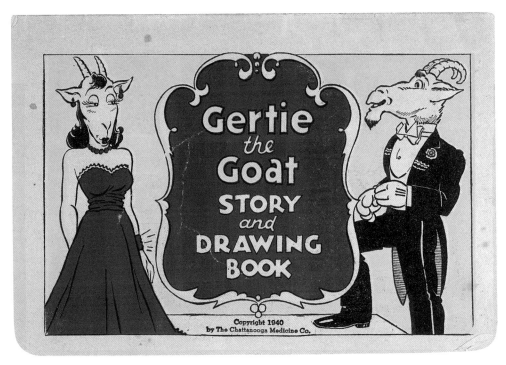

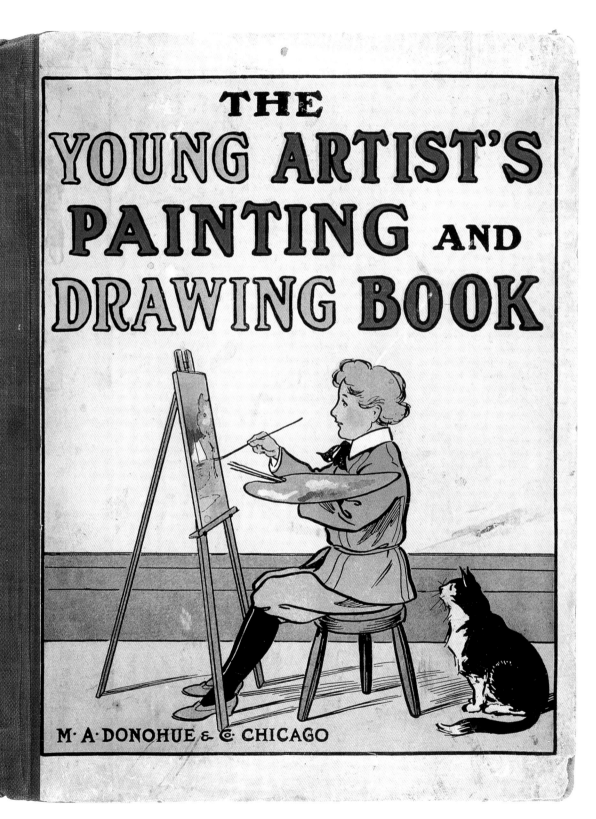

THE
YOUNG ARTIST'S
PAINTING AND
DRAWING BOOK

M·A·DONOHUE & C° CHICAGO

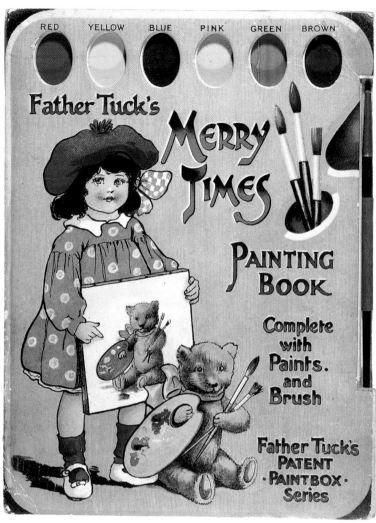

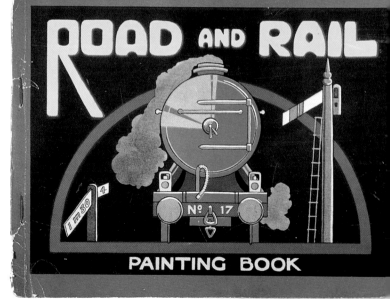

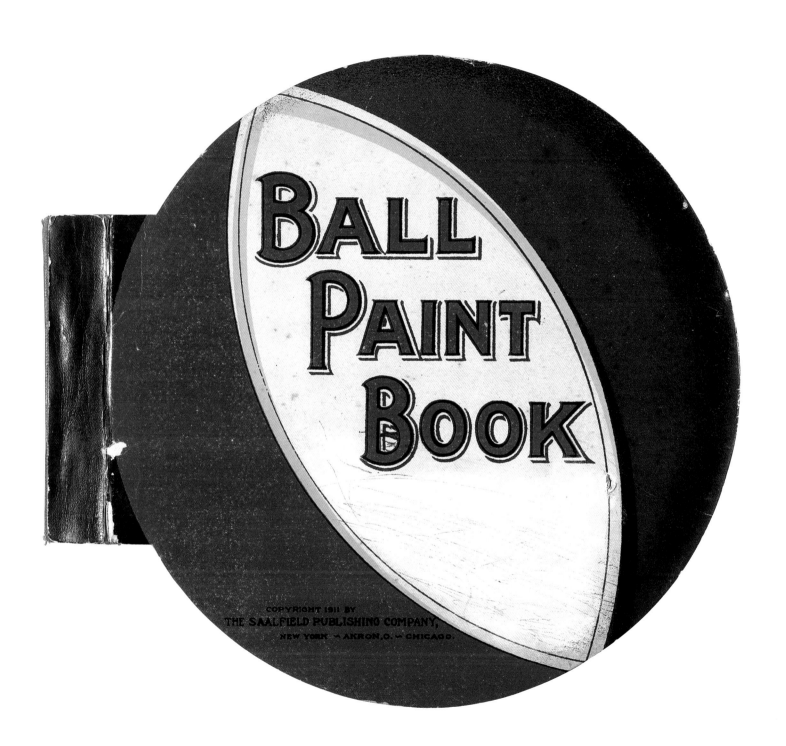

BALL
PAINT
BOOK

COPYRIGHT 1911 BY
THE SAALFIELD PUBLISHING COMPANY,
NEW YORK — AKRON, O. — CHICAGO.

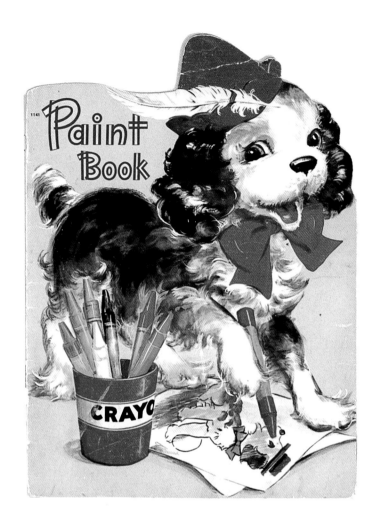

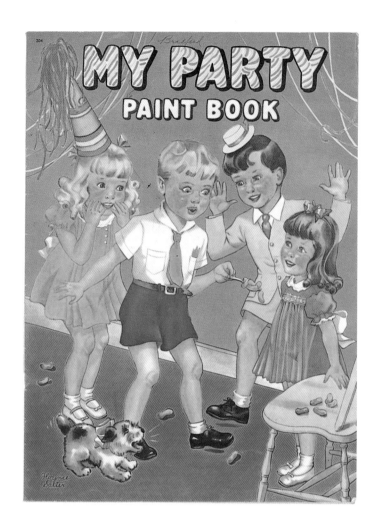

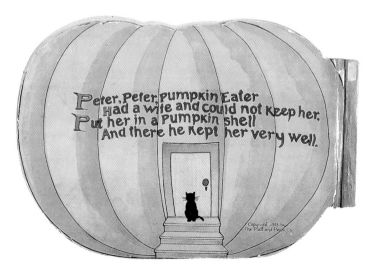

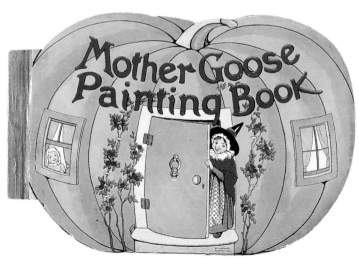

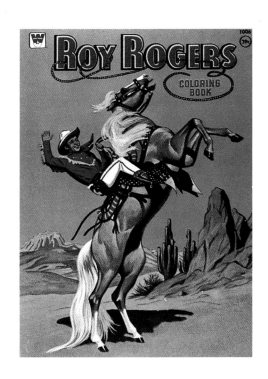

My first coloring book in the 1950's was a revelation for me. Here was another world, an alternative world waiting my choices and my hand to bring it to life! And so...a Periwinkle Blue Trigger galloped frolicingly across a Silver and Gold prairie under a bright Tangerine sky. It would seem I owe much of my success in the illustrating world to one particular *Roy Rogers Coloring Book*.

Cooper Edens

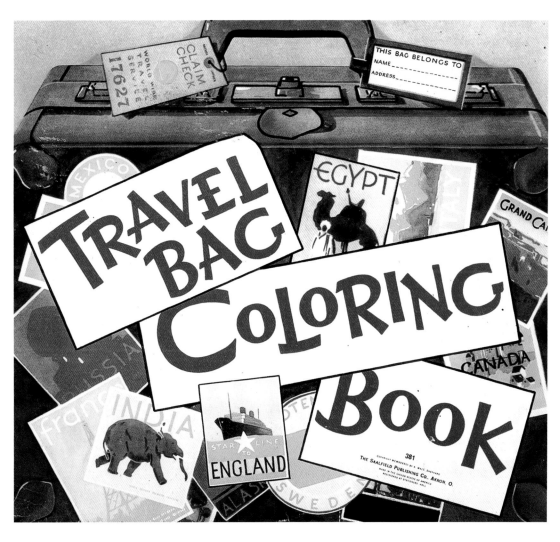

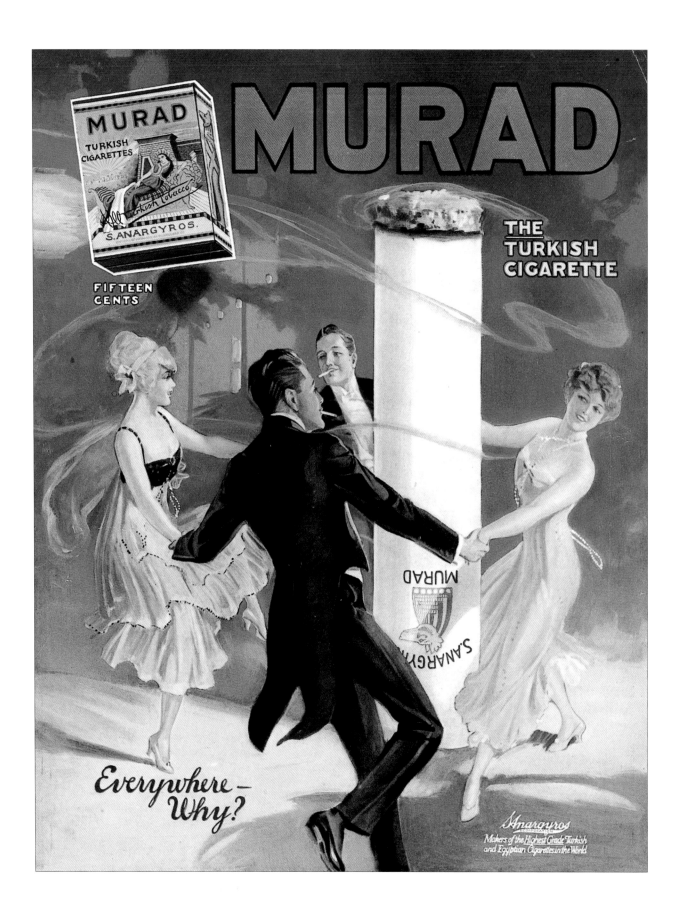

"We have a powerful wish to see and appreciate the world we inhabit, but life dulls our perceptions. We do not fully see the faces of those we live with, the details of the streets we travel, or even the objects we handle. Religion, philosophy, and science all seek, in their different ways, to put us in closer touch with the truth of existence. Photographs help us, for a moment, to see the subjects as if for the first time. People thronged to the first motion pictures because they saw, in the flickering images, the truth of things.

Alteration of scale is a means by which we can be forced to see. When we experience an adventure through tiny people our perspective is completely changed, A house cat apparently as large as a horse, or a spool of thread five feet high confront us like strangers. This freshening of our vision is one of the strongest appeals of the miniature."

Welleran Poltarnees, *The Fascination of the Miniature*

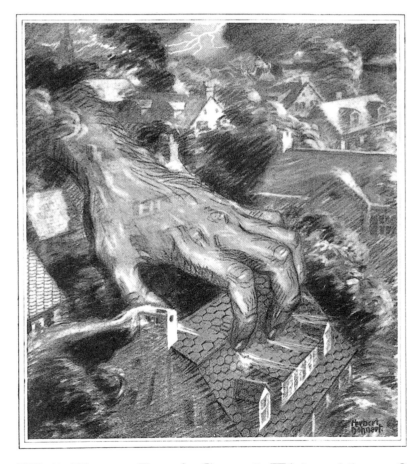

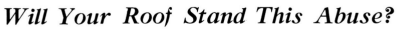

Will Your Roof Stand This Abuse?

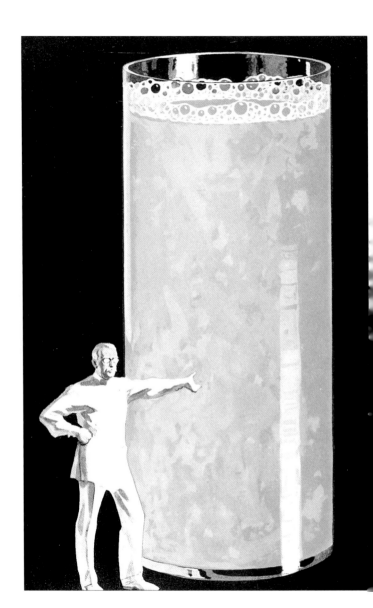

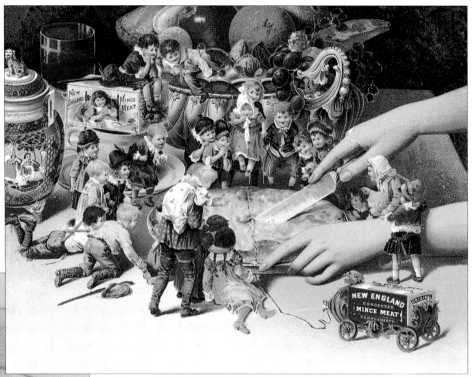

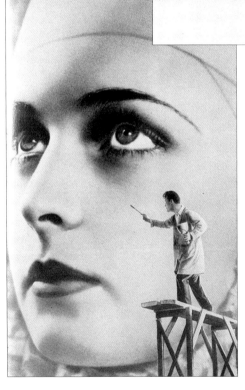

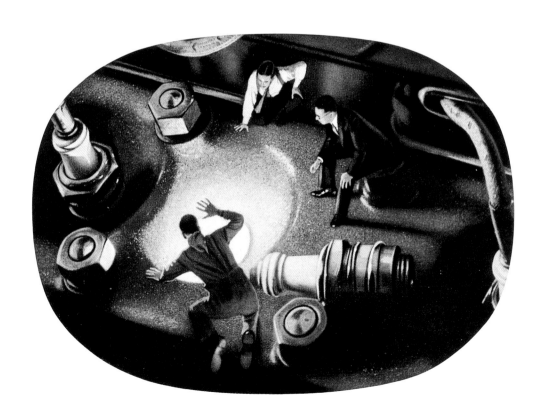

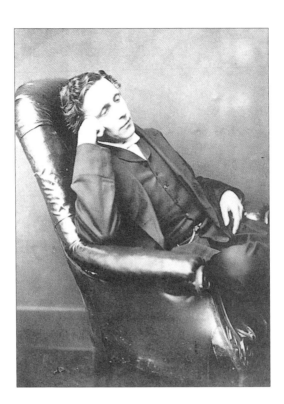

Charles Dodgson (Lewis Carroll) writing to Gertrude (Chataway):

9 December, 1875

This really will not do, you know, sending one more kiss every time by post: the parcel gets so heavy that it is quite expensive. When the postman brought in the last letter, he looked quite grave. "Two pounds to pay, sir!" he said. "Extra weight, sir!"…"Oh, if you please, Mr. Postman!" I said, going down gracefully on one knee (I wish you could see me go down on one knee to a Postman—it's a very pretty sight). "Do excuse me just this once! It's only from a little girl!"

…I promised him we would send each other *very* few more letters. "Only two thousand four hundred and seventy, or so," I said. "Oh!" he said. "A little number like *that* doesn't signify. What I meant is, you mustn't send many." So you see we must keep count now, and when we get to two thousand four hundred and seventy, we mustn't write any more, unless the postman gives us leave.

Christ Church, Oxford.
28 October, 1876

My Dearest Gertrude:

You will be sorry, and surprised, and puzzled, to hear what a queer illness I have had ever since you went. I sent for the doctor, and said, 'Give me some medicine, for I'm tired.' He said, 'Nonsense and stuff!

You don't want medicine: go to bed!' I said, 'No; it isn't the sort of tiredness that wants bed. I'm tired in the face.' He looked a little grave, and said, 'Oh, it's your nose that's tired: a person often talks too much when he thinks he nose a great deal.' I said, 'No, it isn't the nose. Perhaps it's the hair.' Then he looked rather grave, and said, 'Now I understand; you've been playing too many hairs on the pianoforte.' 'No, indeed I haven't!' I said, and it isn't exactly the hair: it's more about the nose and chin.' Then he looked a good deal graver, and said, 'Have you been walking much on your chin lately?' I said, 'No.' 'Well!' he said, 'it puzzles me very much. Do you think that it's in the lips?' 'Of course!' I said. 'That's exactly what it is!'

Then he looked very grave indeed, and said, 'I think you must have been giving too many kisses.' 'Well,' I said, 'I did give one kiss to a baby child, a little friend of mine.' 'Think again,' he said; 'are you sure it was only one?' I thought again, and said, 'Perhaps it was eleven times.' Then the doctor said, 'You must not give her any more till your lips are quite rested again.' 'But what am I to do?' I said, 'because you see, I owe her a hundred and eighty-two more.' Then he looked so grave that the tears ran down his cheeks, and he said, 'You may send them to her in a box.' Then I remembered a little box that I once bought at Dover, and thought I would some day give it to *some* little girl or other. So I have packed them all in it very carefully. Tell me if they come safe, or if any are lost on the way.

These modest works, by anonymous artists, shine with quiet authority.

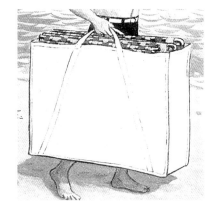

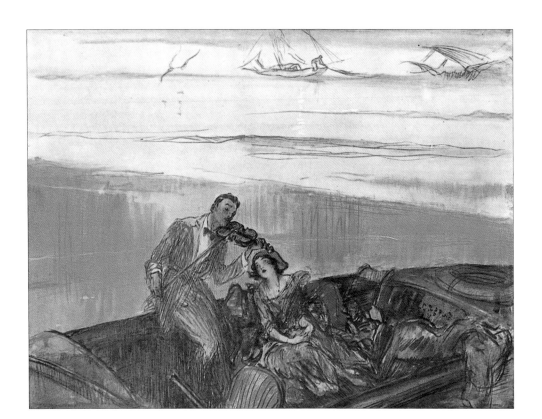

A frequent image in popular art is a man and a woman, or men and women, together in a small boat. Boating, in one form or another, is a frequent romantic activity. The underlying thought is that people in love are isolated from the rest of the world as people are when they are afloat. This small, and slightly risky excursion is a trial for the longer and riskier journey of marriage.

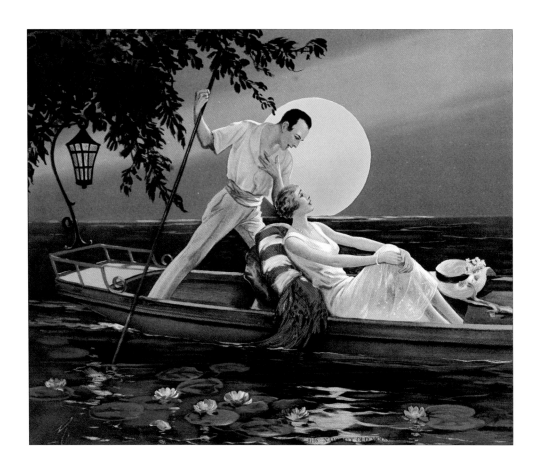

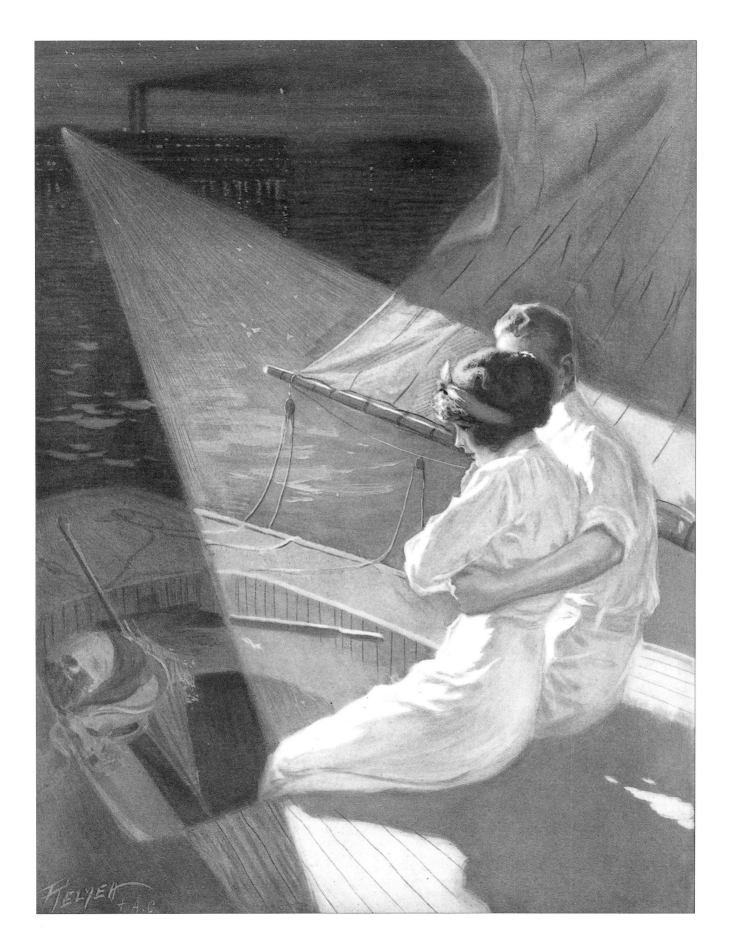

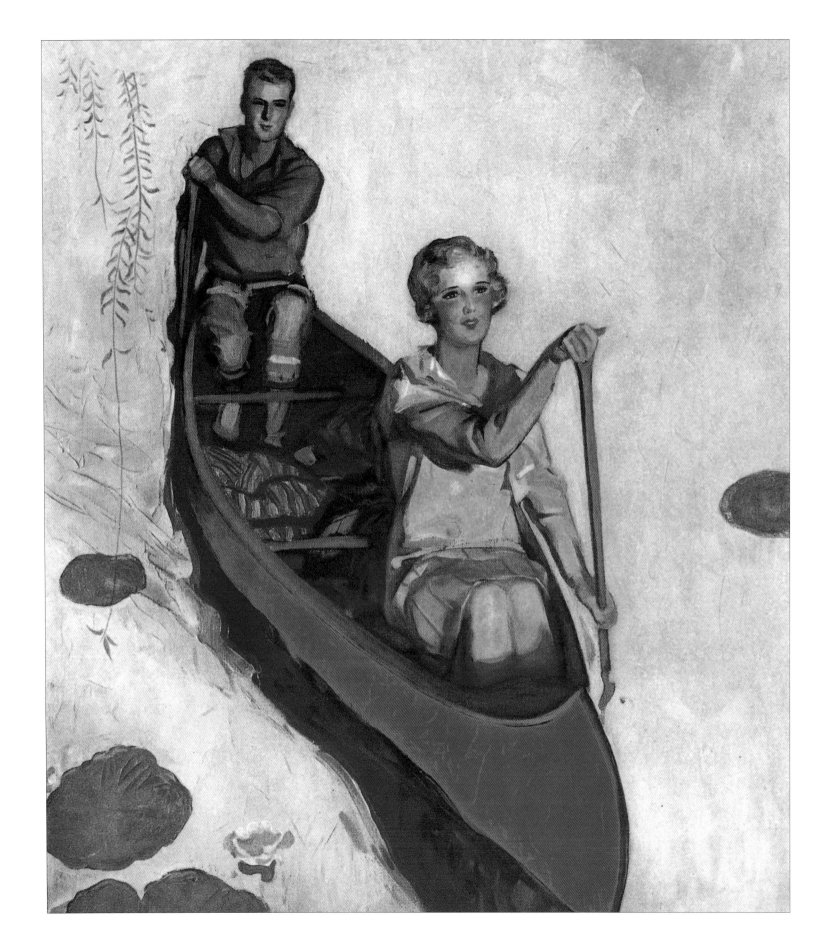

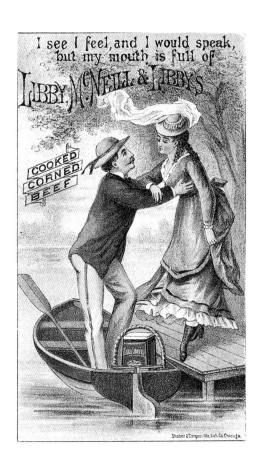

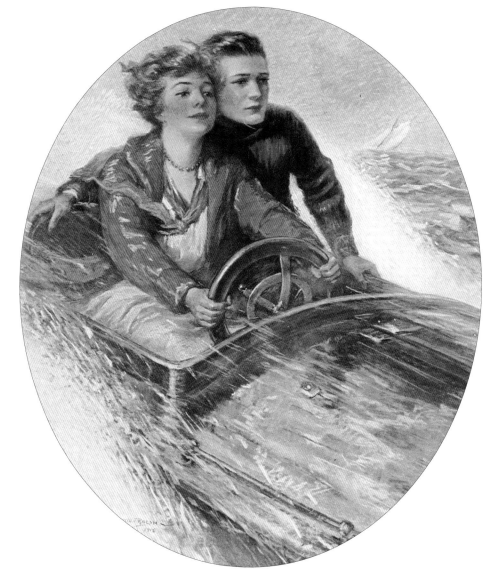

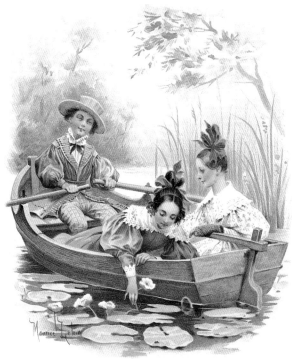

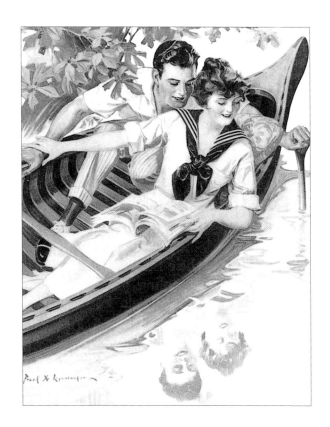

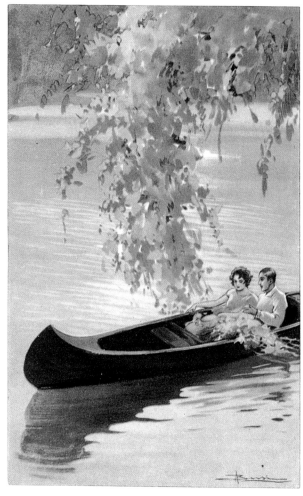

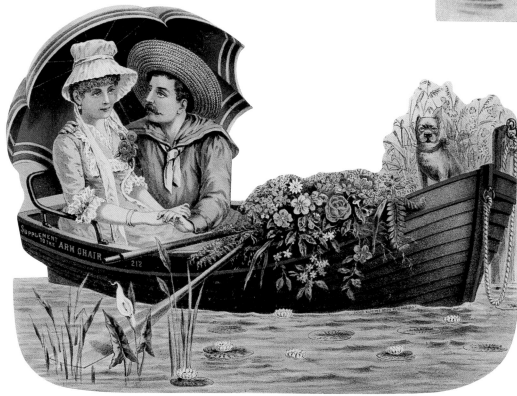

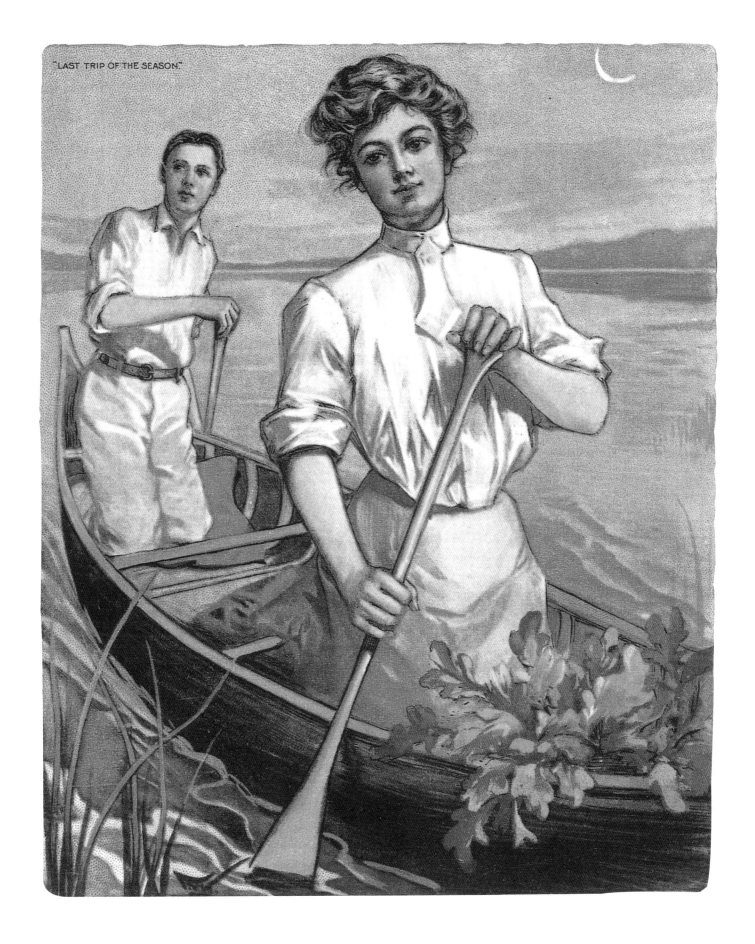

"LAST TRIP OF THE SEASON."

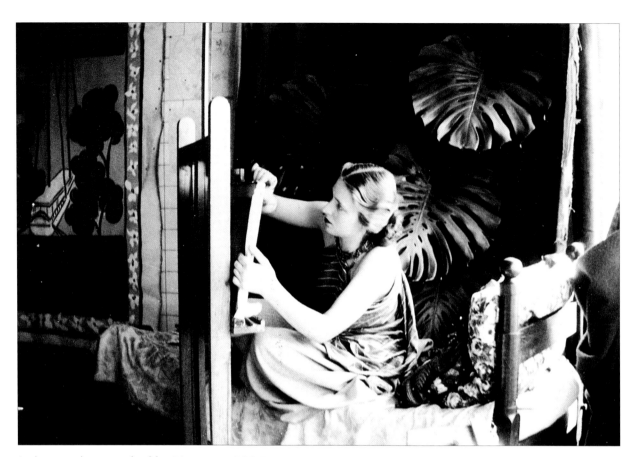

Lydia, as photographed by Matisse, c.1935.

Lydia Delectorskaya was first hired as an assistant by Matisse in 1935, when Matisse was 65 years old. She eventually posed for many of his paintings, including the Pink Nude. Lydia compiled a book of her photographs illustrating the various stages of Matisse's works in progress. For the Pink Nude there were 24 stages, of which 8 are shown here.

Matisse once asked a trick question to Aragon: "Why does the painter 'have to have' a model if he intends to deviate from it?" Matisse answered, "If there were no model one would have nothing from which to deviate."

Matisse considered the model as a point of departure and needed it most in order to "leave it behind," with the slow removal of anything the painter considered superfluous.

"In the photographs of successive, rejected stages of the paintings," notes Lydia Delectorskaya, "he could consider which errors he had made and could see for himself if he had inadvertently destroyed something essential or whether, on the contrary, he had taken a step forward."

Right:
The Pink Nude. Henri Matisse 66 cm x 92 cm, 26" x 36".
The Baltimore Museum of Art, Baltimore, Maryland

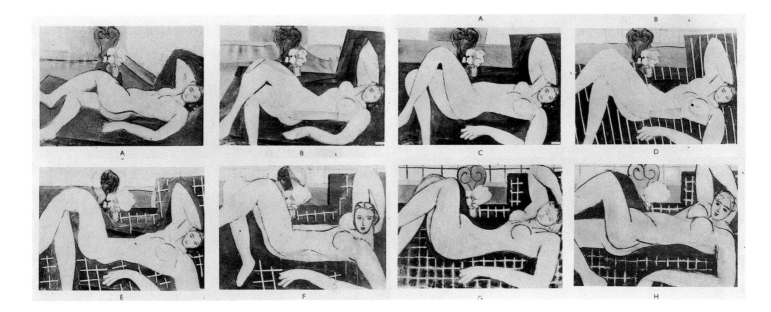

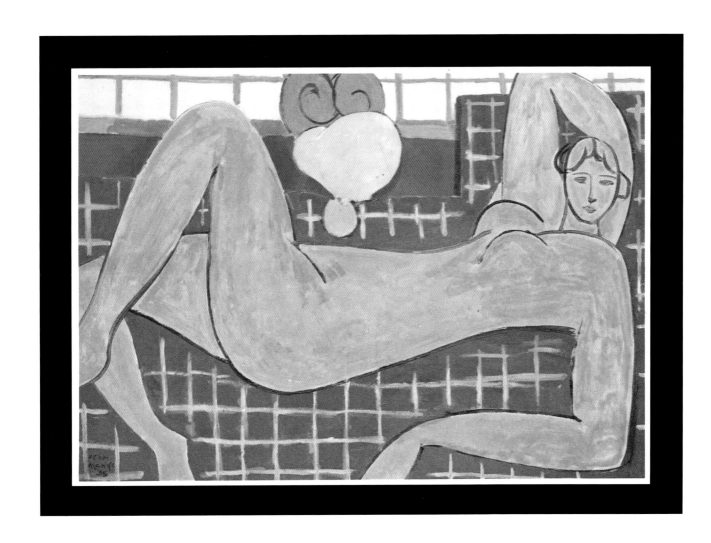

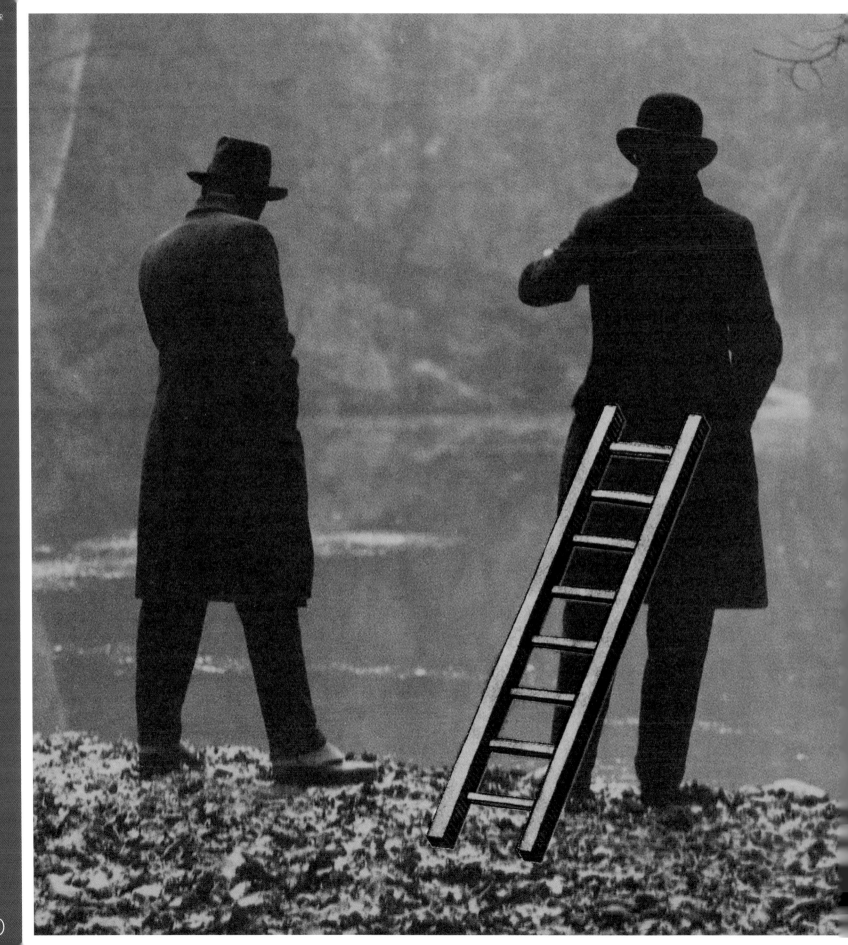

David Hockney once wrote of "The power of distraction." I've always been a fan of this idea, for when I read I am so often distracted by small pieces of the writing which seem to have a presence and power of their own.

This collection of anecdotes and miscellany found their way to me over years of such distraction.

They were collected for pleasure, without thought of publication, so they may be incorrectly worded or imperfectly attributed in a few instances. To their authors my thanks and where appropriate, my apologies.

• • • • • • • •

Cuskoy, a town in eastern Turkey, is called the "bird village" with good reason. Its inhabitants have perfected a language system of chirps, tweets, and twitters almost indistinguishable from authentic bird sounds. The people of Cuskoy developed this unique system because of a ravine and a river which bisect their village and an almost daily fog that prevents the use of hand signals.

Charles Berlitz, *Native Tongues*

• •

Jacob Burkhardt tells a story of a Venetian merchant who was present at one of Savonarola's *Auto-da-Fe's*. He watched them make a great pyramid of objects to be burned: false hair and beards, scents and toilet articles, mirrors, chessboards, playing cards, lutes and harps, volumes of Latin and Italian poets, among them Petrarch and Boccaccio, and finally two tiers of paintings, chiefly of beautiful women. When the pyramid was ready, he offered 22,000 florins for the lot. The Florentines refused, commissioned his portrait to be painted on the spot, and burned it with the rest.

Mary McCarthy, *Venice Observed*

• • •

Before 1653, Valentine greetings had to be delivered by hand. The first mailboxes in Europe were erected in Paris in 1653, but they did not last long because messengers afraid of losing their jobs put mice in them.

• •

In the late 1600's the finest instruments originated from three rural families whose workshops were side by side in the Italian village of Cremona. First were the Amatis, and outside their shop hung a sign: "The best violins in all Italy." Not to be outdone, their next door neighbors, the family Guarnerius, hung a bolder sign proclaiming: "The Best Violins In All The World!" At the end of the street was the workshop of Anton Stradivarius, and on its front door was a simple notice which read: "The best violins on the block."

Freda Bright

Dear Diary: On a recent visit to The Metropolitan Museum of Art, I was standing near two women who were admiring a painting. One of the women remarked: "What a beautiful painting. I wonder who the artist was?"

The other volunteered to find out and walked over to read the wall plaque beside it. She reported that the painting had been done by Circa, in 1878.

"Oh," the first woman said, "of course, Circa the Greek."

"No," the second woman replied. "You're thinking of Zorba. Circa was Italian."

• • •

It is said that Queen Elizabeth of the UK thinks the world smells of wet paint, because wherever she goes, a team of decorators will be round the corner putting a fresh coat on any wall she is likely to pass. I imagined as a child that my world was created much like this, only the decorators were not simply applying new paint, but, under the direction of God, building the world itself, a false reality of sets and props. Around any corner I approached I imagined them to be hurriedly constructing the scenery I would soon behold, while behind me, they were busily dismantling what I had just seen. I imagined that one day I would take an unexpected turn, and catch them out.

Benjamin Woolley

• •

One spring Princess Ateh said: "I have grown accustomed to my thoughts, and to my dresses. They always have the same waistline, and I see them everywhere, even at the crossroads. Worst of all, they make it impossible to see the crossroads anymore."

One day, hoping to amuse her, the princess's servants brought her two mirrors. They were much like other Khazar mirrors. Both were made of shiny salt, but one was fast and the other slow. Whatever the fast mirror picked up, reflecting the world like an advance on the future, the slow mirror returned, settling the debt of the former, because it was as slow in relation to the present as the other was fast. When they brought the mirrors to Princess Ateh, she was still in bed and the letters had not yet been washed off her eyelids. She saw herself in the mirrors with closed lids and died instantly. She vanished between two blinks of an eye, or better said, for the first time she read the lethal letters on her eyelids, because she had blinked the moment before and the moment after, and the mirrors had reflected it. She died, killed simultaneously by letters from both the past and the future.

Milorad Pavac, *Dictionary of the Kazars*

• • •

She said the hardest thing to teach her three-year old kid was what was alive and what wasn't. The phone rings and she holds it out to her kid and says, "It's Grandma. Talk to Grandma." But she's holding a piece of plastic.

Laurie Anderson

I remembered a story of how Bach was approached by a young admirer one day and asked, "But, Papa Bach, how do you manage to think of all these new tunes?" "My dear fellow," Bach is said to have answered, according to my version. "I have no need to think of them. I have the greatest difficulty not to step on them when I get out of bed in the morning and start moving around my room."

<div align="right">Laurens Van der Post</div>

• •

This afternoon I did not want to see an unknown gentleman, but coming out of the house...I find the gentleman still waiting, hoping to see me all the same. I talked to him and learned that he is by profession a whaleman. Immediately, the same instant, I request him to send me several vertebrae of this mammal. He has promised to do so with the utmost diligence. My capacity to profit from everything is unlimited. In less than an hour I have listed sixty-two different applications for these whale vertebrae—a ballet, a film, a painting, a philosophy, a therapeutic decoration, a magical effect, a hallucinatory method both Lilliputian and psychological because of its so-called phantasies of grandeur, a morphological law, proportions exceeding human measurement, a new way to pee, a brush. All this in the shape of a whale's vertebrae.

<div align="right">Salvador Dali</div>

• • •

An art dealer (this story is authentic) bought a canvas signed 'Picasso' and traveled all the way to Cannes to discover whether it was genuine. Picasso was working in his studio. He cast a single look at the canvas and said: "It's a fake." A few months later the dealer bought another canvas signed Picasso. Again he traveled to Cannes and again Picasso, after a single glance, grunted: "It's a fake." "But cher maitre," expostulated the dealer, "It so happens that I saw you with my own eyes working on this picture several years ago." Picasso shrugged: "I often paint fakes."

<div align="right">Arthur Koestler</div>

• •

Ten years later I came across what I took to be the key to this compulsive fictionalizing, these sweet dreams of heroic warfare and flight, when I read Vladimir Nabokov's afterward to a reissue of *Lolita*. The germ of the novel, Nabokov said, lay in a newspaper clipping about a captive ape in a Californian research institute. Given paints, brushes and paper, the ape spent a year producing indecipherable blobs of color. Electrodes were attached to its brain. Its tormentors tried to encourage it by subjecting the animal to a perpetual exhibition of simple pictures of female apes, bananas, tall trees and other likely objects of fantasy. At last it came up with the goods. Sheet after sheet of paper was painted with shaky black parallel lines. The chimpanzee was drawing the bars of its own cage.

<div align="right">Jonathan Raban, *Coasting*</div>

Among the many legends that surround the Nepalese Gurkhas of the British Army is the story of a paratroop regiment in the Second World War. The leader of the regiment asked for volunteers for a particularly dangerous drop behind enemy lines. About half the Gurkhas promptly stepped forward. The leader then went through what the volunteers would be asked to do. Halfway into his explanation, a surprised voice piped up from the back: "Oh, you mean we can use parachutes." Every remaining Gurkha joined the volunteers!

London 1985, *Radio Times*

• • •

[Lewis Milestone directing *All Quiet on the Western Front*]—Hell! I didn't have an ending for 'All Quiet' until the last minute. The studio took the film away from me, said it was too long, too down-beat. They wanted to end it with some damned montage of thousands of marching soldiers singing some damn-fool patriotic song, flags waving, all that crap. Withdrew the money. I was sunk. There was just me and the camera crew left, in a car, coming away from the studio with the bad news. I have never been so low in my life. A picture, and no ending. Stopped at an intersection. Rain so heavy you couldn't see out the car. The windscreen wipers squeaking across the glass, backwards and forwards, they made a funny noise. It seemed to me like Schmetterling, Schmetterling, and suddenly I got it! I got the end. We turned right round and went to a butterfly farm, bought boxes of them. Found a building just off Sunset, in all the rain. No lights, so we used the headlamps of the car, turned them on a muddy bit of land, let the butterflies...most of the flew away, but one little fellow, he just settled happily in the warmth of the lamps, flitting his wings. I reached out my hand, very gently to take him, and then he was gone. And that was the last shot of *All Quiet on the Western Front.*

• •

We take a blue billiard ball and shrink it to one-thousandth of its original size. It is now like a mote in a sunbeam, to use Vedic language. We shrink it another million times. It is now completely out of the see-touch realm. Color is caused by the reflection of a particular wavelength of light in that range to which our eyes are sensitive. Our shrunken billiard ball is now smaller than these wavelengths. It cannot reflect light. What is its color? It has none. It does not even have an absence of color. The term simply does not apply.

• • •

In the late seventeenth century, M. de Villayer designed a clock so arranged that when he reached for the hour hand at night, it guided him to a small container with a spice inserted in place of numbers, a different spice for each hour of the night. Even when he could not see the clock, he could always taste the time.

Daniel Boorstin

A 20th Century-Fox executive in Paris arranged for an exhibit of the fake paintings used in the movie *How to Steal a Million*. He phoned Howard Newman of the New York office, who said the fakes could not be shipped because they were on tour. "What should I do?" asked the Paris man frantically. "Get some originals," said Newman. "Nobody'll know the difference."

. .

One of the Second Republic's most grandiose ideas has been to establish a Museum of Copies in Paris, which would reproduce the best paintings of the whole world, and in 1851 four painters were dispatched to copy the works in the National Gallery in London.

Theodore Zeldin

. . .

Shortly before I left Beirut in June 1984, I decided that I wanted to see what remained of the Beirut National Museum, which was located right on the Green Line. The aged director, Emir Maurice Chehab, was only too happy to give me a tour I shall never forget.

Soon after the Lebanese civil war began, and the museum was engulfed in cross fire, the most precious pieces were spirited away and hidden, but the big statues, bas-reliefs, and stelae in the main halls were impossible to move. So Chehab had wooden frames built around each piece and then filled those frames with poured concrete, leaving each priceless object encased in a foot of protective cement that would repel any bullet or shell. When the war ended they could be chiseled out. This made for a rather unusual display, because when you entered the Gallery of Ramses on the ground floor, what you saw were huge square pillars of cement reaching up from the floor to various heights. But Chehab, who had been the director of the museum for ages and knew every piece by heart, gave me a tour anyway. He would point to a 15-foot-high, 5-foot-wide block of cement and say, "Now, here we have a spectacular Egyptian statue found at Byblos." Then he would walk a few paces and point to another identical block of cement and say in a voice brimming with enthusiasm, "And here is one of the best preserved stelae of early Phoenician writing." For emphasis he would pat the pillar of cement. After about an hour of this I started to believe I could actually see the objects he was describing.

Thomas Friedman, *From Beirut to Jerusalem*

. .

Meeting a friend in a corridor, Wittgenstein said: "Tell me, why do people always say it was natural for men to assume that the sun went round the earth rather than that the earth was rotating?" His friend said, "Well, obviously, because it just looks as if the sun is going round the earth." To which the philosopher replied, "Well, what would it have looked like if it had looked as if the earth was rotating?"

When we came in she had her chair sideways, by the window, looking out at the snow, and she said, without even looking up to know that it was us, that the doctor had said that sitting and staring at the snow was a waste of time. She should get involved in something. She laughed and told us it wasn't a waste of time. It would be a waste of time just to stare at snowflakes, but she was counting, and even that might be a waste of time, but she was only counting the ones that were just alike.

Ann Beattie

• • •

The Uruguayan political prisoners may not talk without permission, or whistle, smile, sing, walk fast, or greet other prisoners; nor may they make or receive drawings of pregnant women, couples, butterflies, stars or birds.

One Sunday, Didasko Perez, school teacher, tortured and jailed for having ideological ideas, is visited by his daughter Milay, age five. She brings him a drawing of birds. The guards destroy it at the entrance to the jail.

On the following Sunday, Milay brings him a drawing of trees. Trees are not forbidden, and the drawing gets through. Didasko praises her work and asks about the colored circles scattered in the treetops, many small circles half-hidden among the branches: "Are they oranges? What fruit is it?"

The child puts a finger on his mouth. "Ssssshhh."

And she whispers in his ear: "Silly. Don't you see they're eyes? They're the eyes of the birds that I've smuggled in for you."

Eduardo Galeano, *Memory of Fire*

• •

[Colette and Paul Masson on the shore of *Belle-Isle-en Mer*]—Paul would take from his pockets his notebook, his fountain pen and a little packet of cardboard cards. "What are you doing, Paul?" "I'm working. I'm working at my job. I'm employed by the Library Catalogue for the Nationale, I'm noting down titles." "Oh...can you do that from memory?" "From memory? What good is that? I'm doing better that that. I've noticed that the Nationale is very poor in Latin and Italian works of the fifteenth century...So until the day when these lacunae are remedied by luck or scholarship, I'm making notes on highly interesting works that should have been written...so at least the titles will maintain the Catalogue's prestige." "But," said I naively, "you mean the books have never been written?" "Ah," he replied with an off-hand shrug, "I can't be expected to do everything."

• • •

As a special treat, a teacher took her class to visit the Museum of Natural History. The children returned home very excitedly, and rushing into his house, one of the little boys greeted his mother exuberantly, saying, "What do you think we did today, Mother! The teacher took us to a dead circus."

Rossini to Louis Engel—When I was writing the Chorus in G Minor, I suddenly dipped my pen into the medicine bottle instead of the ink; I made a blot, and when I dried it with sand (blotting paper had not been invented then) it took the form of a natural, which instantly gave me the idea of the effect which the change from G Minor to G major would make, and to this blot all the effect–if any–is due.

• •

Thousands of Red Army troops appeared never to have been in a big city before (during the invasion of Berlin). They unscrewed light bulbs, and carefully packed them to take home, under the impression that they contained light and could be made to work anywhere.

Cornelius Ryan

• • •

Yet Auric himself once told me that in scoring *Blood of a Poet* he produced what is commonly known as love music for love scenes, game music for game scenes, funeral music for funeral scenes. Cocteau had the bright idea of replacing the love music with the funeral, game music with love, funeral with game. And it worked–like prosciutto and melon.

Ned Rorem

• •

"When may I come and visit you?" asked Marcel. "I'll paint your portrait." "My dear, I can give you no address, since perhaps tomorrow I shall have none. But I'll come to see you, and I'll mend your coat, which has a hole in it so big that you could move all your furniture through it without paying any rent." "What a sweet girl," said Marcel, as he walked slowly away, "a very goddess of gaiety. I'll make *two* holes in my coat."

Henri Murger, *Scenes of Bohemian Life*

Our language defines the way we perceive the world. Most straight thinking allows for very little modulation of understanding.

The no-good rounder
A good square meal
Straighten up and fly right
OK, now we're square
A one-track mind
Coming apart at the seams
Straight "A's"
Straight-laced
Three squares a day
Let's tie up the loose ends
Lay your cards on the table
As the crow flies
The straight scoop
Cut and dried
Unwavering glance
A clean slate
Straight to the source
Straight from the horse's mouth
Go straight to the top
Don't rock the boat
Keep a stiff upper lip
Pointed questions
Stiff as a board
Straight as a pin
Right as rain
In a rut
Keep the record straight
Walking tall
I'm much too kinky
This is getting out of hand
That's a new "twist"
Side-stepping the issue
Give it to me straight
That's marginal
Oblique comment
Feeding her a line
Shoulder to shoulder
The bottom line
In the groove
Right on
On the level

On the up and up
Forward!
Off the beaten path
Those are the breaks
Sign on the dotted line
Square your shoulders
True bearings
Straight to the point
Let's take a break
Hard to pin down
Strung-out
Keep your nose to the grindstone
Ear to the ground
Shoulder to the wheel
That's the way the cookie crumbles
The cornerstone of our society
Stand at attention
State boundary lines
Don't make waves
Hold that line
Square shooter
Square deal
Spiraling inflation
The ground rules
What's my line?
Don't lose track
Right off the bat
On the beam
Don't jump to conclusions
The Domino theory
Working stiffs
Shoot first, ask questions later
Steer a middle course
What's your point?
Down to earth
Off the wall
Square your shoulders
The economy sags
Take the bull by the horns
Look him squarely in the eyes
I walk the line

THREE MONKEYS

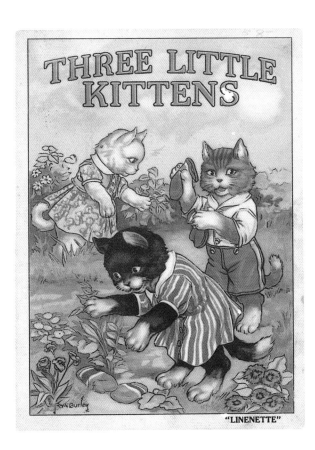

"LINENETTE"

Three symbolizes spiritual synthesis, and is the formula for the creation of each of the worlds. It represents the solution of the conflict caused by dualism. It forms a half-circle comprising: birth, zenith and descent. Geometrically it is expressed by three points and by the triangle. It is the harmonic product of the action of unity upon duality. It is the number concerned with basic principles, and expresses sufficiency, or the growth of unity within itself. Finally, it is associated with the concepts of heaven and the Trinity.

J.E. Cirlot

Julia Pond, who wrote under the pseudonym Sallie Sparkle, accepted a *dare* to write a book in which every word began with the letter S, and published it in 1877 (on September Seventeenth, Seventy-Seven in San Francisco) under the title Shadrach Steven's Speculations. Once she rode over the Rocky Mountains, strapped in an arm-chair which rested on the cow catcher of a railroad train.

The original book was 18 pages long, and sold for $5 a copy.

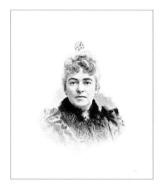

This picture (above) is of Mrs. Julia A. Pond as she appeared when acting as official hostess to the Woman's Exhibit in the Michigan Building at the Chicago World's Fair in 1893.

SECULAR Shadrach, slowly sauntering sea - ward, spied Selena Stebbins selecting shells, stones, sea-mosses. She sat serenely separating some saturated sub-marine sea-weeds, saving small sprays, softly singing sweet soul-inspiring strains. Shadrach stood spell-bound, silently studying such sweet simplicity. Seeking some shadeful, sheltered seat, Shadrach sat soliloquizing ; steadfastly surveying simple sun-burnt Selina — seraphic sea-shore songstress !

Soft summer skies, sparkling sunshine, solemn sounding surgful seas, stretching shell-strewn silvery strands—surrounded semi-conscious Shadrach.

Suddenly, some smart - spirited, self - defensive sand - wasps spitefully stung serenely settled Shadrach. Springing several steps side - wise, simultaneously scattering sundry satanic sand-wasps, severely stung, suffering, *swearing*, Shadrach S. Stevens skedaddled.

———

SUBSEQUENTLY, Shadrach subserviently sought Squire Stebbins' society; socially sipped soda, sherry, sweet spiced sangaree; smoked superfine segars.

Smitten Shadrach, sedulously sought Selina's sanctioning smile; studiously sought salubrious sport; sailed; strolled seaward; sometimes sought silent sequestered shade.

Shadrach seldom solicited sister Sarah's society. Selina seldom stayed solacing Squire Stebbins: she socially shared Shadrach's sportive saunterings; she sketched skillfully—so Shadrach subtly selected secluded sceneful spots; she submitted sketchy specimens—steadily securing Shadrach's satisfactory smiles. Sweet, sunny, sparkling Selina! she scattered Shadrach's senses.

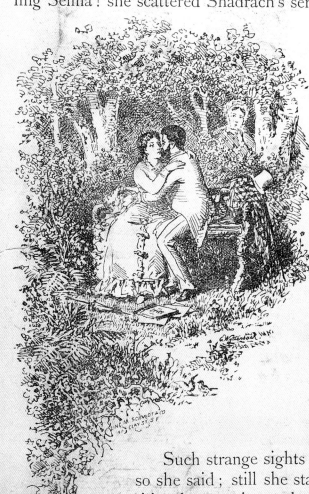

Surveillant Sarah, soon surmised something strange. She said: "Shadrach's surely sparking somebody." So she slyly sought sequestered shade, satisfied she'd see Shadrach's sweet-heart: stealthily stepping, she soon secured safe shelter. Separating some spreading shrubs, she spied Shadrach smacking sweet submissive Selina!

Sarah seemed surprised. "Simpleton!" said she sneeringly, "sparking Squire Stebbin's step-daughter! silly simpering school-girl!"

Such strange sights shocked sedate sister Sarah, so she said; still she stayed, safely screened, surreptitiously surveying such sacred soul-entrancing scenes.

"See!" shouted Selina, suddenly spying suspicious storm signs, "sheet-lightning suffuses sombre

skies, superseding smiling sunshine, signifying storm!" Such statements startled Sarah : she scampered.

"Sprinkling, sure!" said Shadrach, speedily securing sundry scrap-book sketches.

Shadrach spread Selina's small silk sunshade; she scrupulously secured snowy skirts, showing symmetrically shaped small - sized shoes. Safely supporting said smiling sweetheart, Shadrach started.

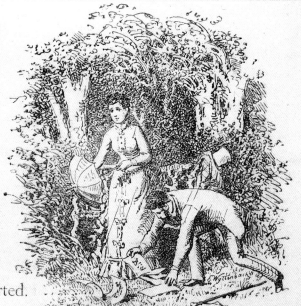

Spattering sprinkles soon saturated Shadrach's span-new stiffly-starched summer suit.

Strange, Selina should show such slight sense : she surveyed storm-spattered Shadrach, sarcastically saying, "sweet specimen!"

Sensitive, shame-faced Shadrach stumbled, scattered scrap - book sketches, smashed Selina's small sunshade stick.

Spontaneously screaming, Selina stood statuesque! Scrutinizing sprawling Shadrach somewhat sternly, she sadly surveyed shattered sunshade, sorrowfully scanned spoiled scrap-book sketches.

Summer showers soon subside; so sparkling sunshine soon supersedes sullen stormful skies.

SELINA'S suitor solicited speedy spousal. She said, see step-father Stebbins. So Shadrach summoned Squire Stebbins — succinctly stating soul-felt sentiments.

Squire Stebbins said, "suppose so;" successive smiles signifying satisfaction.

Sylvester Smith solemnized Shadrach's spousal. September sixteenth saw sweet, sprightly Selina, scarcely seventeen,

Shadrach Stevens' spouse.

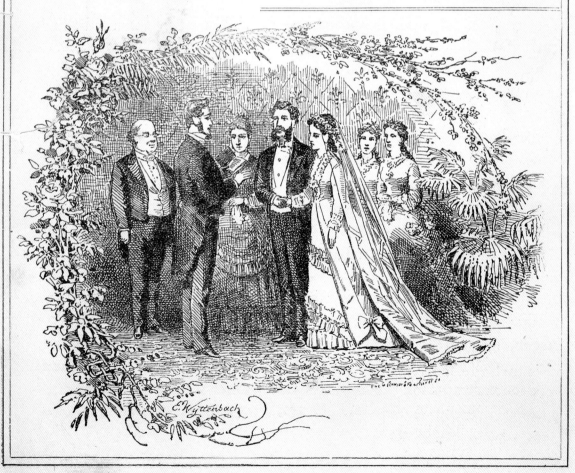

(14)

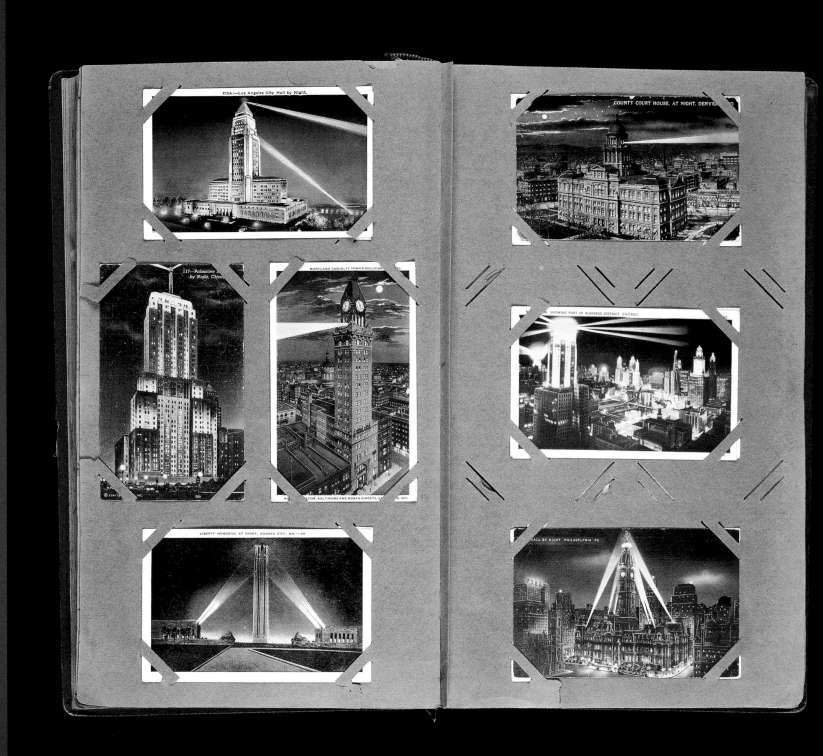

searchlights

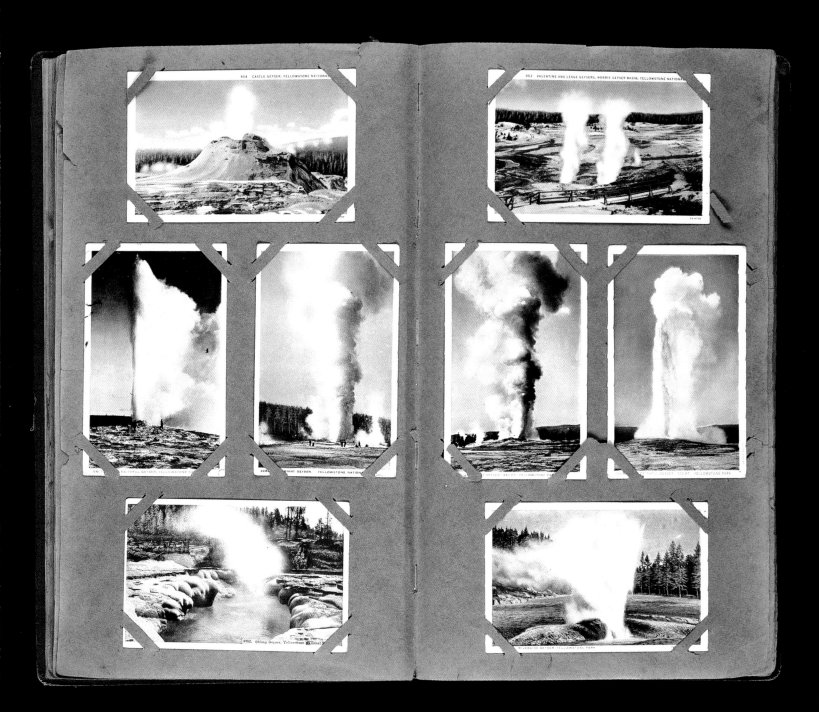

geysers

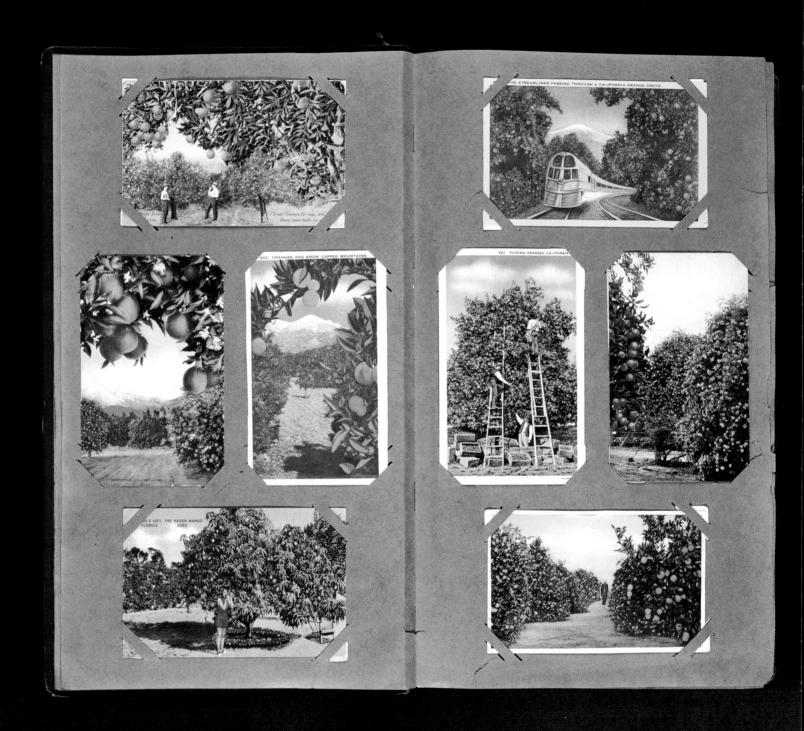

orange groves

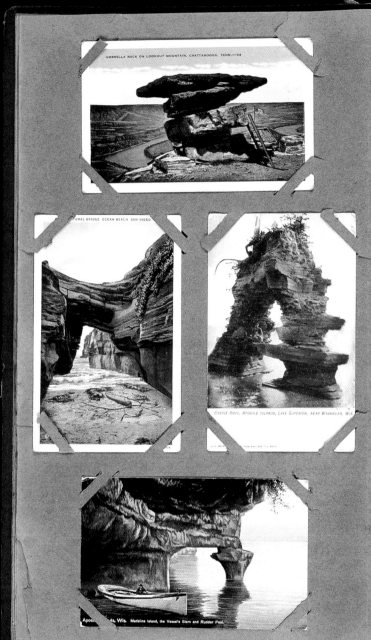

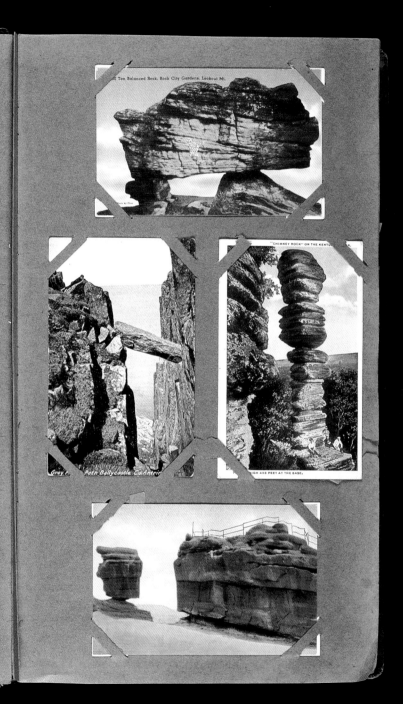

balenced rocks

sacks & bales

crashing waves

empty highways

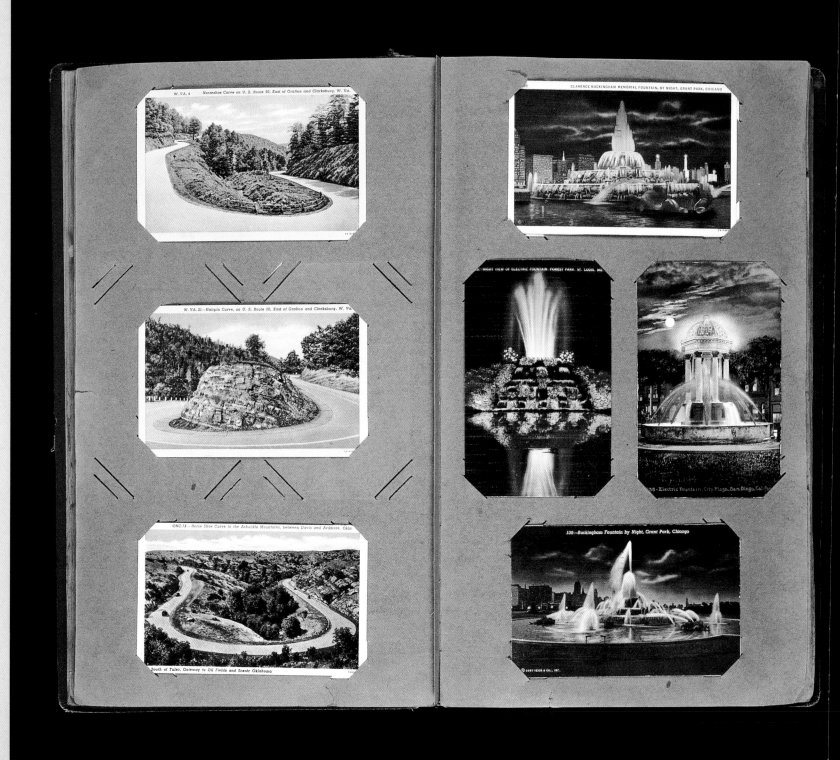

u-turns

colorfully lit fountains

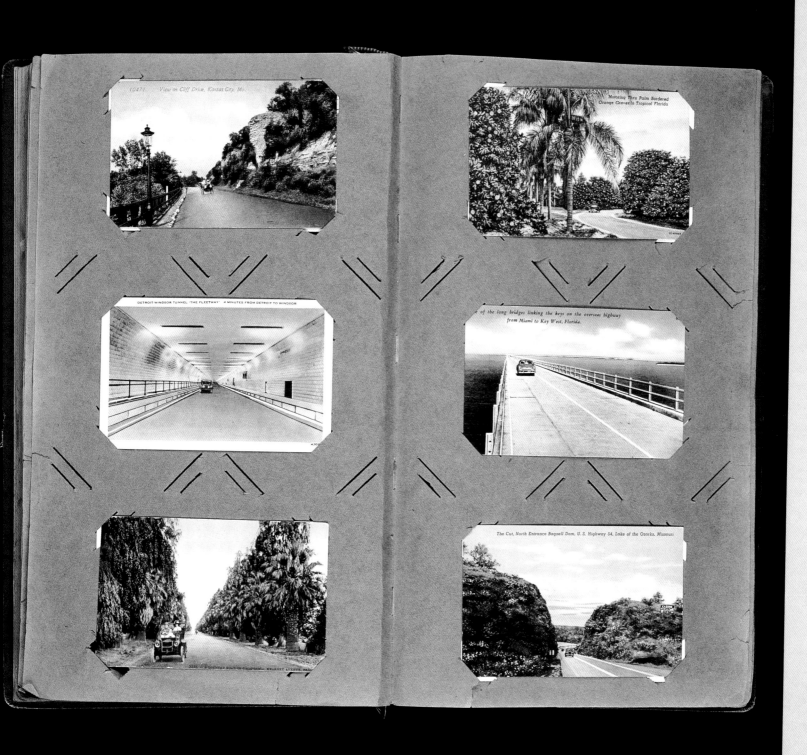

red car approaching

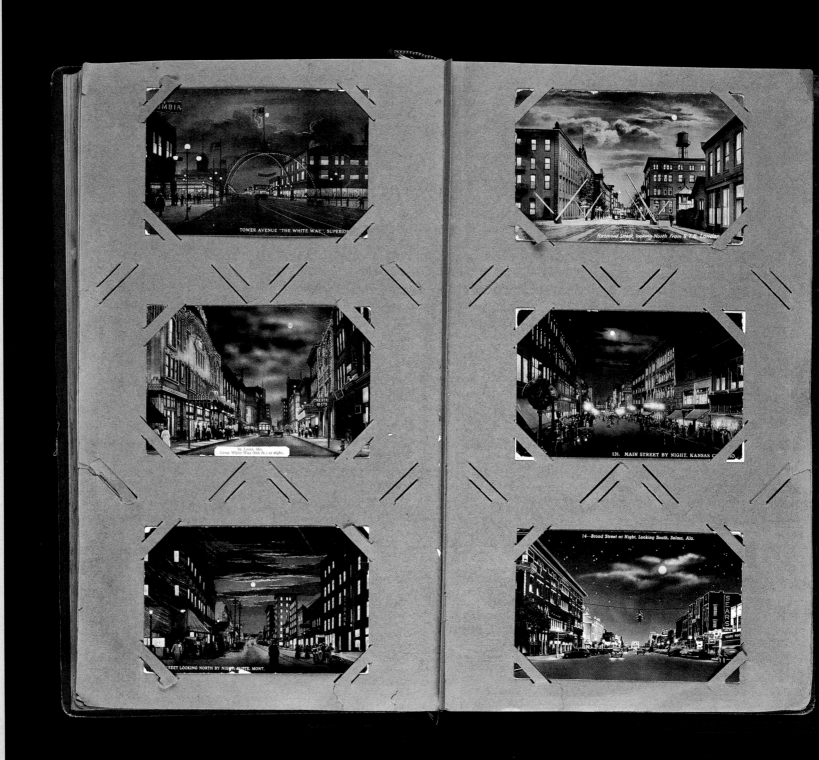

moonlit mainstreets

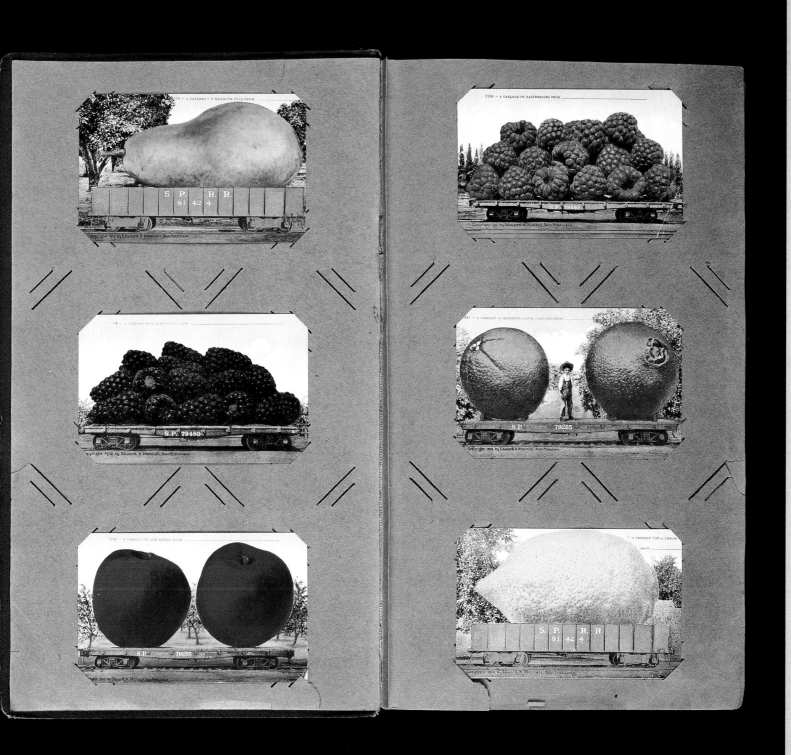

fruit on railroad cars

NATURE-MAN on Plantashun

10 KOMANDMNTS OV NATURE
3 KARDZ 5c

(Am riting a book "Natura," on Nature-life in South Se Ilandz, where I livd 7 yrz, mostly nude, & mostly on froot & nuts, on mi own land, in mts. ov Tahiti. Formerly I spent 4 yrz at Stanford University, 2 yrz being as preparatory medikl student.)

1. Let's get away from smoky, dusty, il-smeling, noizy, krouded, dangercus, im-moral kondishunz ov sity-life, freing our selvz from temtashun & wearing xsite-ment.

2. Let's gradually tuffen & strengthen our bodiz by streching-xrsize, jimnastix, swiming, oil-masazh, **sun-bathing,** inteli-jent fasting, **gardening,** &s, alwayz breething deeply ov **pure** air, til we kan safely sleep out-doors in gd wethr. (For 6 munths I slept on top of wind-mil wotr-tank.) Take gd kare of ize & teeth. 8 hrz work, 8 rest, 8 pla.

I find Van Houten's "Back to Nature Foods" xlnt. 323 South Hill Street, L. A.

3. Eet only when **hungry,** & ov **natural** unkookt fd, uz-ing litl or no stuf like salt (a kloggr & stiffener) no pepr, spise, te, kofy, likr, &s, (nerv-rakrz) no sweets nor strongly asid fd, (mind-weekenrz & tooth-spoilerz). Froots & nuts kontane all the stuf for body-bilding for bipedz. Nuts, with apl, peech, persimun, sun-kured oliv, buttr-pear (avoka), banana, &s, wel-ripened from **helthy** trez or pamz, r more **vitalizing,** delishus & beutiful than eny uther fd. (I'v uzd no kookt fd since 1912.) Hav ur own wel-tild orchard-aker, & fire-proof wind-mil wotr-tank hous in midl. Vizit tropix.

4. More **simplisity.** More fun & song. Let's stop ovr-eeting, ovr-rest, ovr-work, (mentl & fizikl), smoking, drinking, gambling, sex-ruining, & extravagans in dres & fd. Reed Dr. Reinhold's bk "Nature vs. Drugs." Xlnt!

5. Take time enuf for good judjment, being moderat in all things **pure** & gd only, & having **sistem** & regularity so far az we kan.

6. Uze klothing only 2 kumfort & protekt, leting need & **nature** set our fashun, in warm wether uzing litl or no klothing az kase & law permit. Begin bare-footing on grass, sand or floor. Reed "Return to Nature" by Just.

7. Xrsize marij relashun only when **helthy,** wel-pre-pared, only 2 bring best children. Even in this trying aje, a **pure,** vigorus woman **kan** bare child every 2 or 2 yrz without ovr-taxing.

8. No that we **kan** keep yung, vigorous, hapy & pros-perus more than 100 yrz by foloing theez helth-hints, avoiding axident & dizeez. Reed Gaze' bk "How 2 Liv Forevr." Kapt. Diamond in S. F., 118 yrz, May, 1914, no meet nor stimulnts for 60 yrz, uzing oliv-oil freely outside & in. Reed bk by Sanford Bennett who reganed uth at 72.

9. Luv **truth** & **duty,** noing that **konshuns,** with hiest intelijens, iz a beutiful gide 2 the **now-hevn,** lisening 2 & reeding only best, axepting only what seemz **reezonabl.**

10. Let's liv by **nature** on **nature** fds, 2 strengthen our bodiz & sweeten our moodz.

Ernest Darling, Nature-Man. Los Angeles, U.S.A.
Sleeps on a hil-top not far away.
43 yrz yung 2 day. 4-5-8-1914.

PRINTED BY A. K. TATE & SON, 709 SOUTH HOPE STREET, LOS ANGELES, CAL.

I inspekted plant of Los Angeles Oliv Growers' Ass'n at Sylmar. Goodz xlnt.

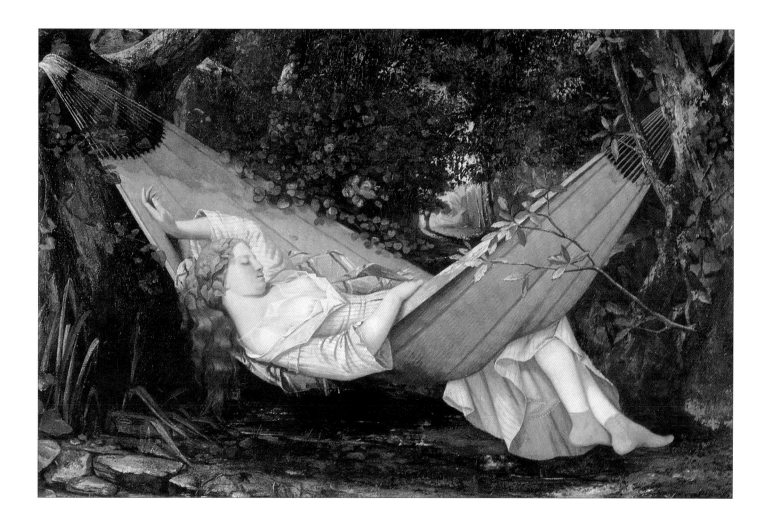

Hammock hæ′mək), Forms: n. 6-9 hamaca, 7 acca, -acco, -ackoe, hammacho, 8 hamacoe, 8-9 hammacoe. ß. 7 hamack(e, hammac(k, -aque, amack, hamock, hammok, 8 hammoc, 8-9 hamac, 7 hammock.

1555 EDEN. Theyr hangynge beddes whiche they caule *Hamacas.* 1596 RALEIGH. They lay each of them in a cotten Hamaca, which we call brasil beds. 1613 R. HARCOURT. Hamaccas, which are Indian beds, most necessary in those parts. 1626 CAPT. SMITH. A Hamacke, the lockers, the round-house. 1638 SIR T. HERBERT Saylers, who...get forthwith into their beds, (or hamackoes) [1677 or hamacks]. 1657 R. LIGON. Lye down and rest them in their Hammocks. 1675 It cannot be so convenient as a Hammaque. 1698 FROGER. There is noting but Famine that can draw them out of their Amacks. 1761 LONDON. Orders were...given for sewing him up in a haacoe, in order to bury him. 1794 To keep the hammacoes in the stantions. 1847 PRESCOTT. Carried on the shoulders of the natives, in *hamacas,* or sedans, of the country. 1804 NELSON. Apr. in Nicholas *Disp.* Seamen's beds and hammocks are very much wanted. 1840 R. H. DANA. I went aboard, and turned into my hammock.

Oxford English Dictionary

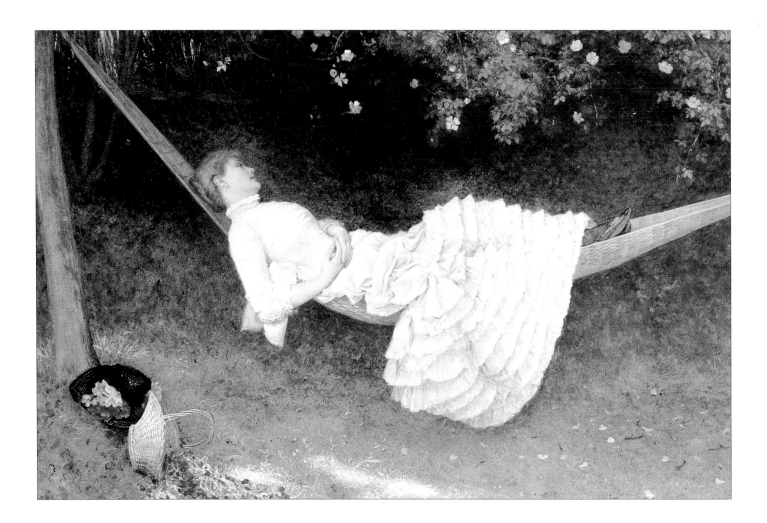

The hammock has become a symbol of luxurious outdoor sleep—the ultimate in relaxation and a well deserved nap. This was equally true in ancient Egypt, throughout the Roman Empire and during the Victorian and Edwardian eras as well. Indeed the hammock is perennially popular and promises to remain so.

The hammock is believed to have derived from a number of needs. In South American rain forests, natives hung from nets slung in trees for safe keeping above raging flood waters and carnivorous beasts. Mongol invaders of China hung camouflaged in woven rope meshing, awaiting their victims while hidden comfortably in tree-tops. North American Indians used the hammock in their burial rituals as an aid to heavenly ascension. Anywhere it is hot we find light nets strung between shady trees.

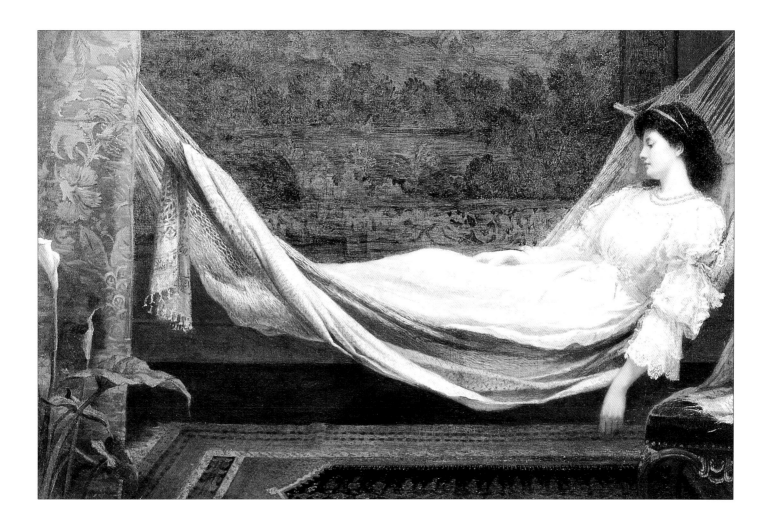

It is from one of these humid climes that the hammock found its name. The aboriginal natives of Brazil used bark from the hamack tree to form their sleeping nets. Shortly after this the idea of the hammock was seized upon by the idle wealthy, landed gentry and simply romantic. It became known as the ideal device to string up on ones grounds—be they grand estate or humble suburban plot—and gently rock away a summer afternoon with a cooling beverage.

Like other essentials, the hammocks invention and immediate acceptance appears to have occurred in many parts of the world almost simultaneously. One thinks of the hammock not so much as an invention but as an inevitability, much like the milk shake or the yo-yo—predestined and necessary because if the sleep of night time is largely for the rehabilitation of the body, the sleep of the day is for the free exploration of the soul—daydreams demand hammocks.

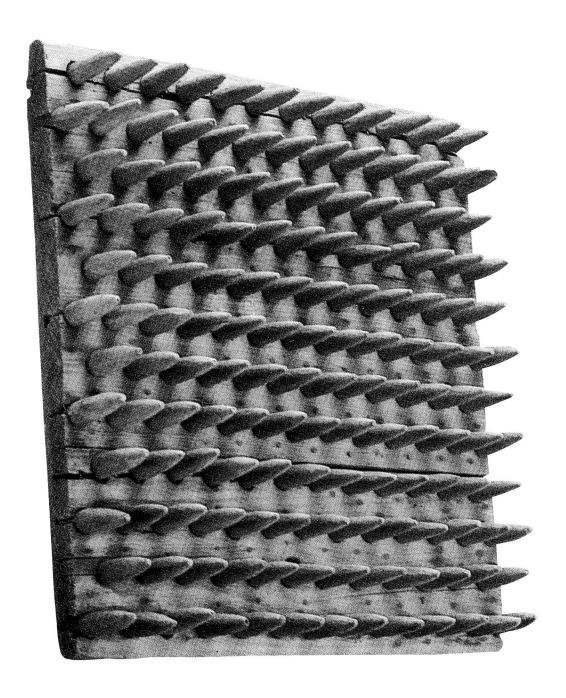

[See page one hundred thirty-eight for identifications]

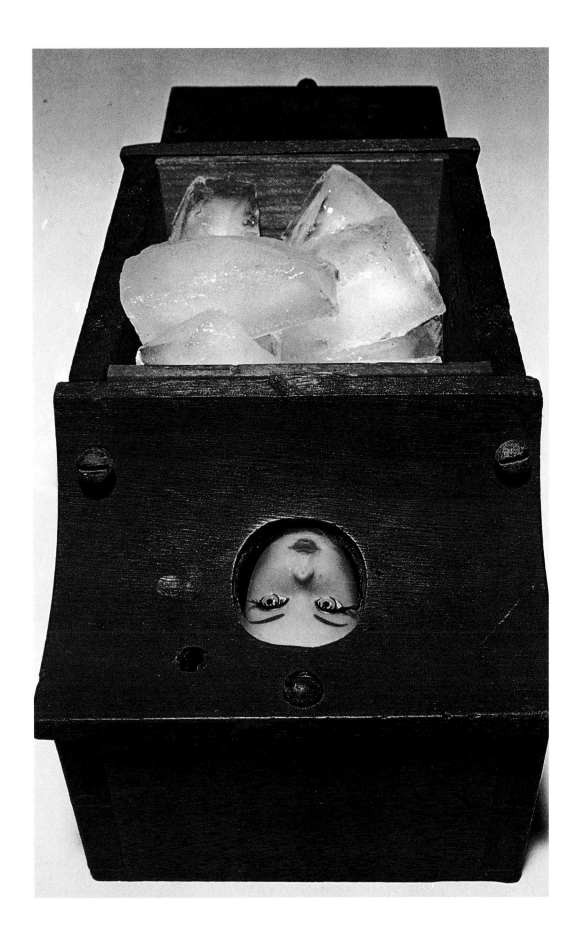

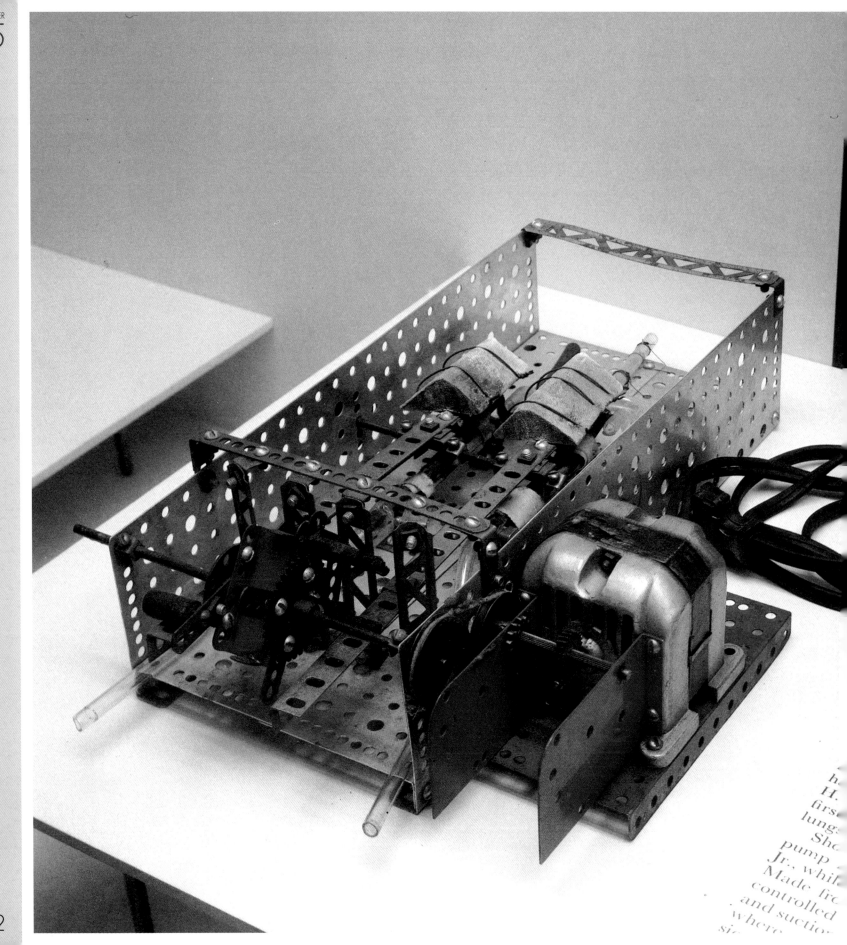

h...
H.
firs...
lungs...
Sho...
pump...
Jr., whil...
Made fro...
controlled
and suctio...
where
si...

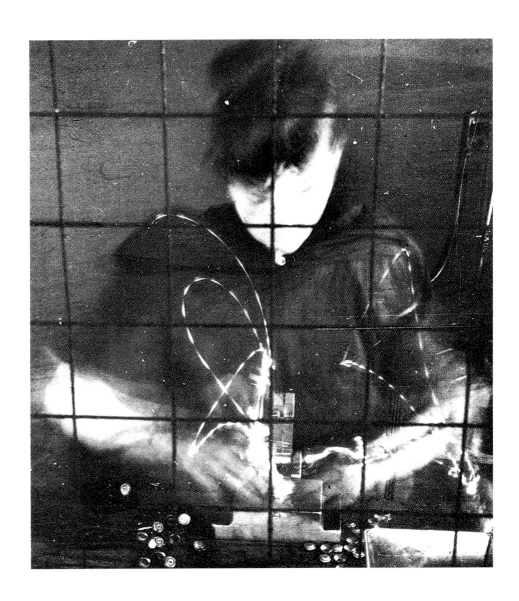

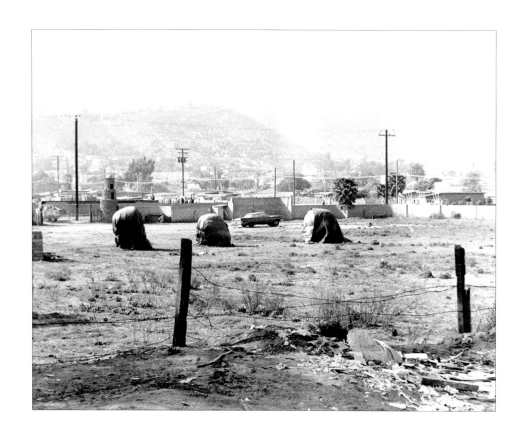

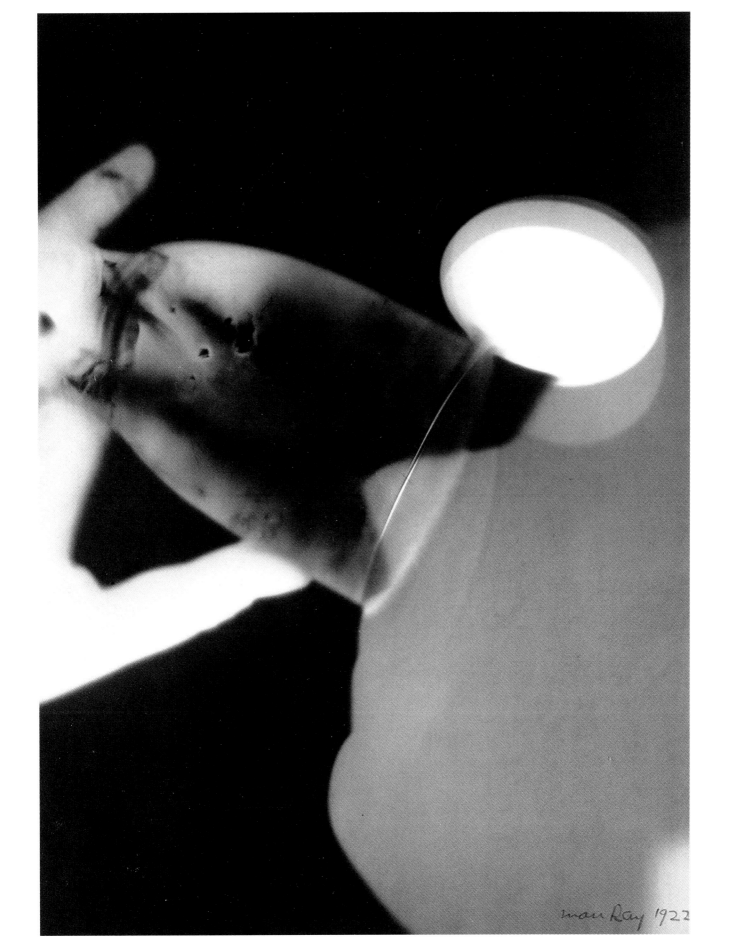

man Ray 1922

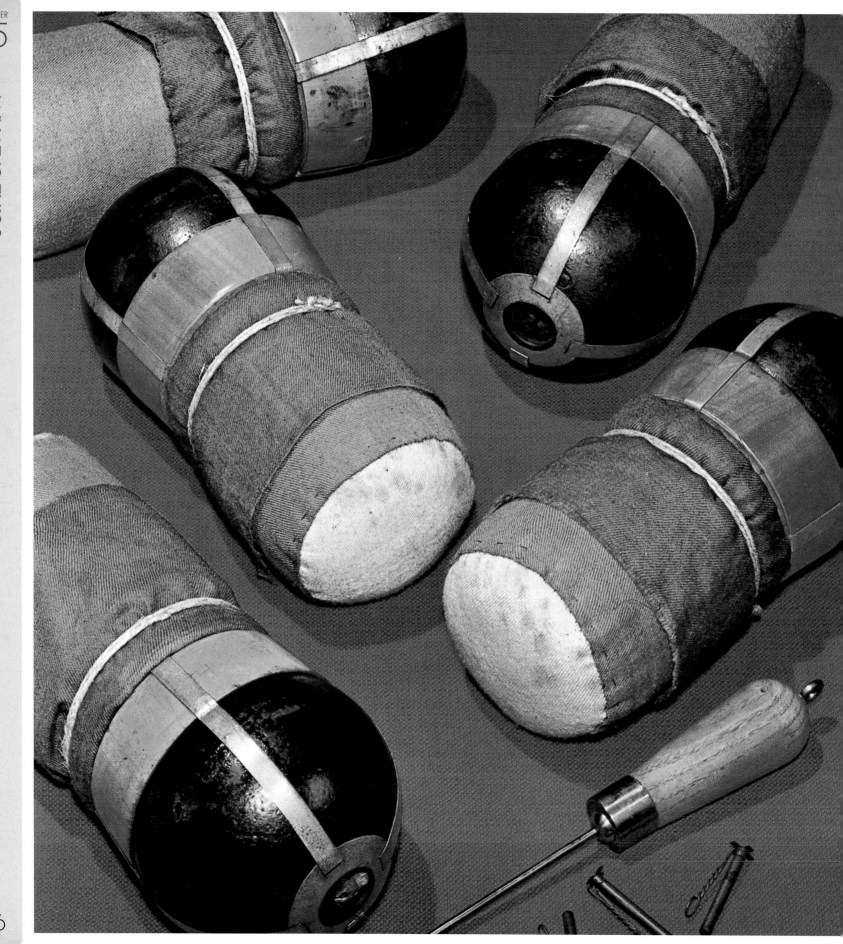

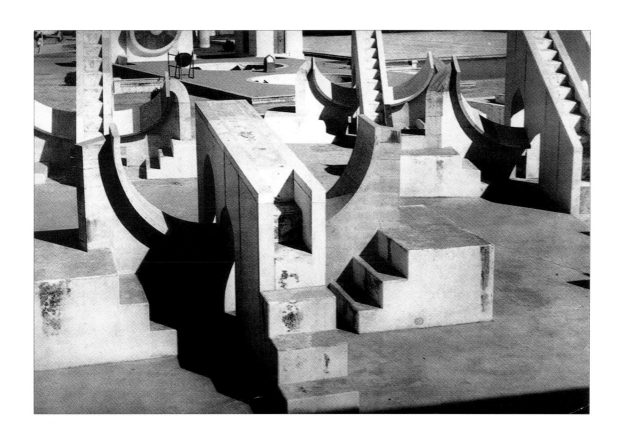

Those things which fall under the senses are the most deeply impressed upon the mind, remain the longest, require most careful examination, and afford material more fruitful in instruction to students, than those things which only present themselves to us in imagination like dreams, and foreshadowed in words only.

Peter Paul Rubens

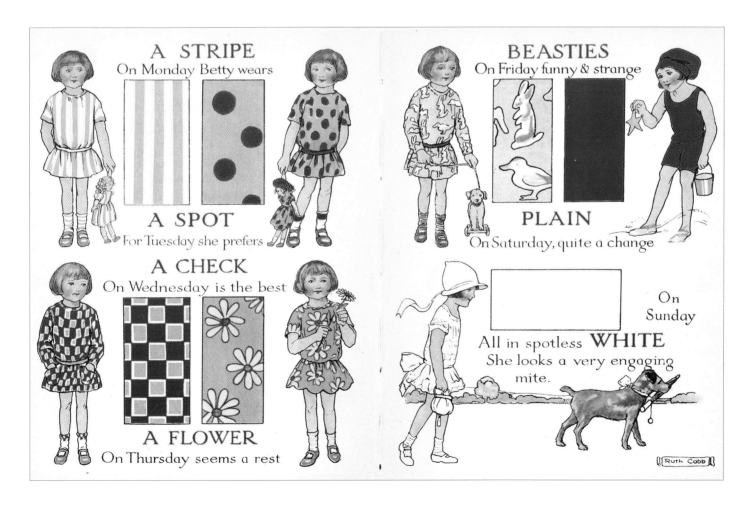

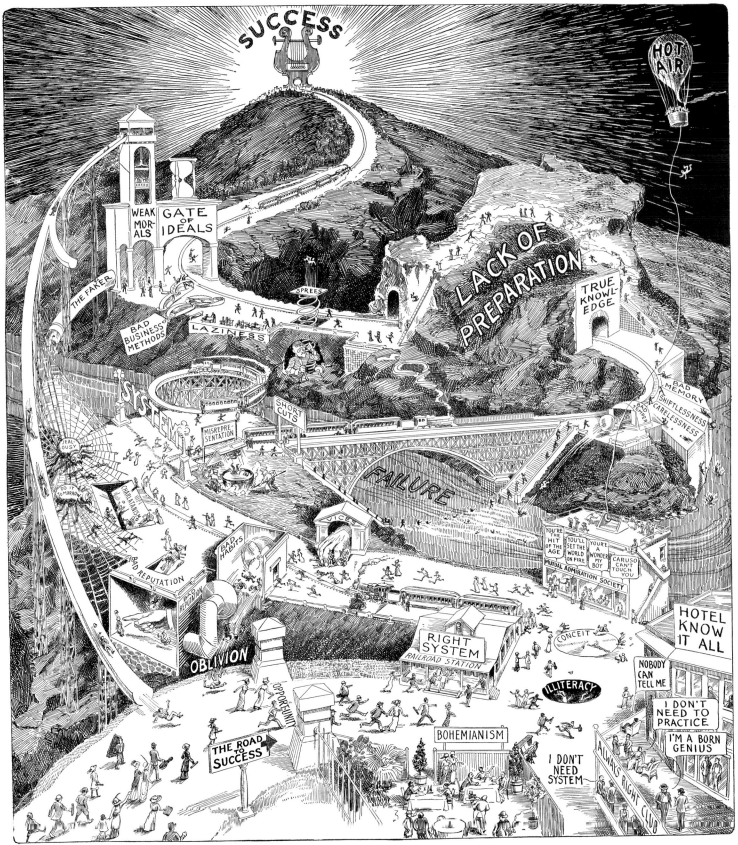

THE ROAD TO SUCCESS.

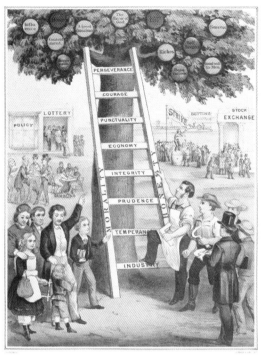

THE LADDER OF FORTUNE

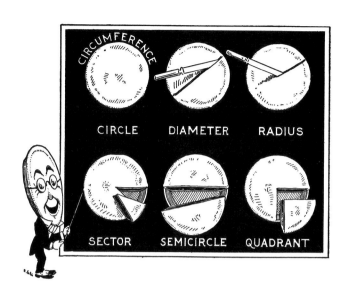

STICK LAYING

One stick
 makes a scout.

Two sticks
 make his tent.

Three sticks
 make his table.

Four sticks
 make his chair.

Five sticks
 make his bed.

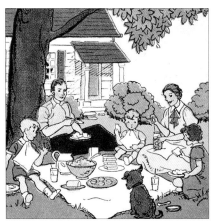
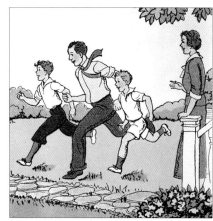

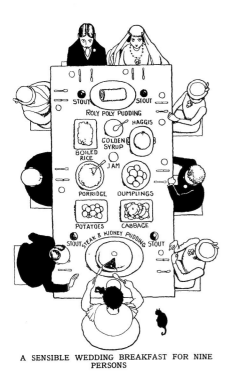

A SENSIBLE WEDDING BREAKFAST FOR NINE
PERSONS

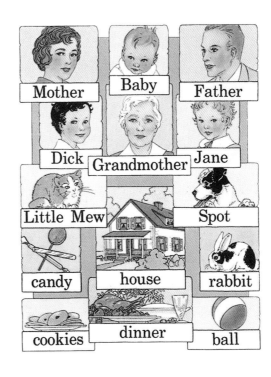

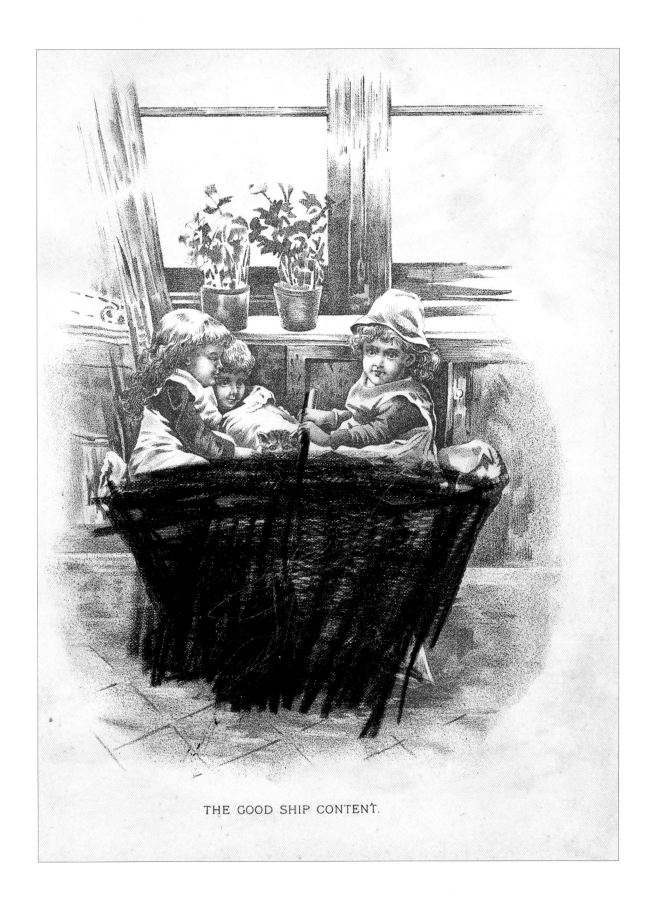

THE GOOD SHIP CONTENT.

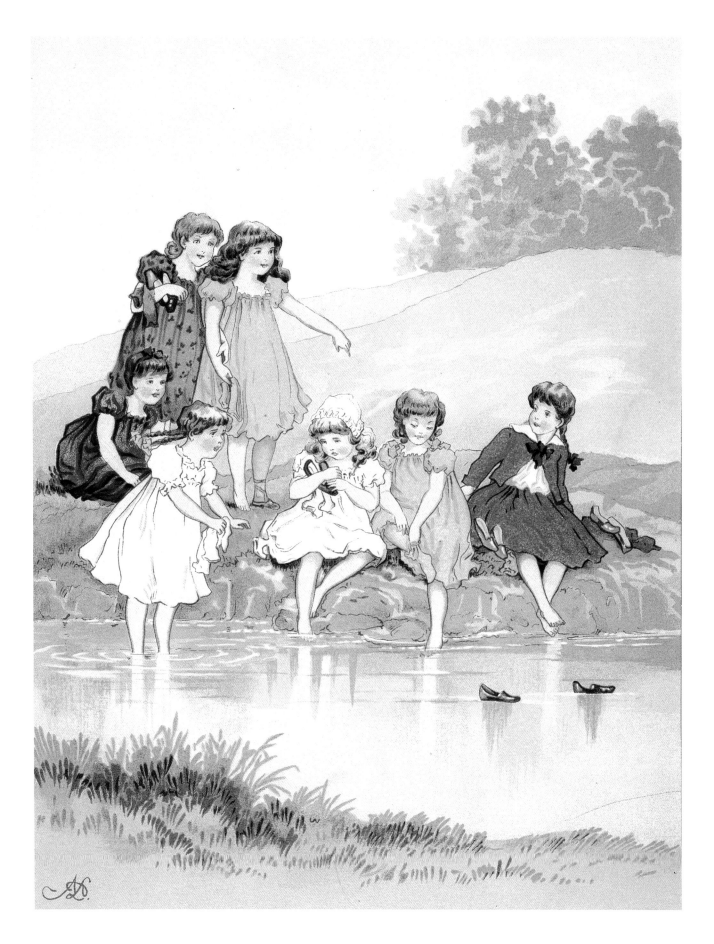

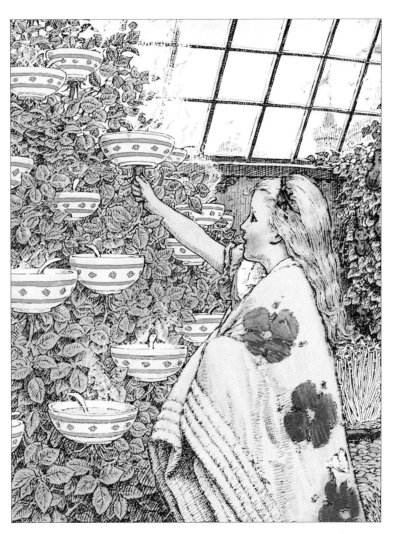

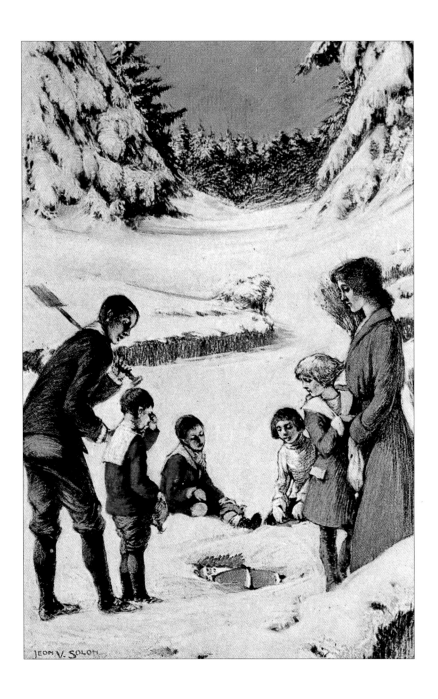

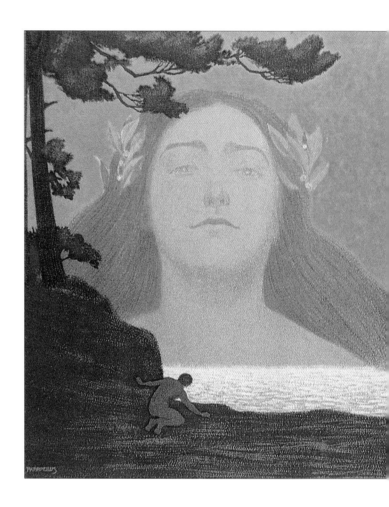

It seems impossible not to take her personally. In twenty years of living through a window from her I guess I have never thought of her as "it."

She made weather, like all single peaks. She put on hats of cloud, and took them off again, and tried a different shape, and sent them all skimming off across the sky. She wore veils: around the neck, across the breast: white, silver, silver-gray, gray-blue. Her taste was impeccable. She knew the weathers that became her, and how to wear the snow.

Ursula K. Le Guin
Writing on the explosion of Mt. St. Helens

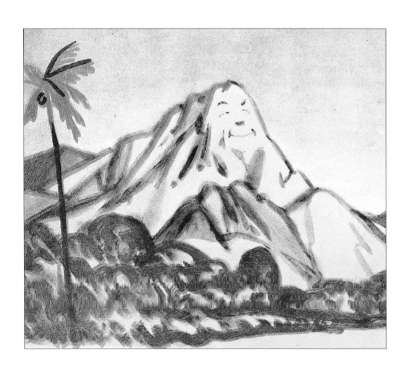

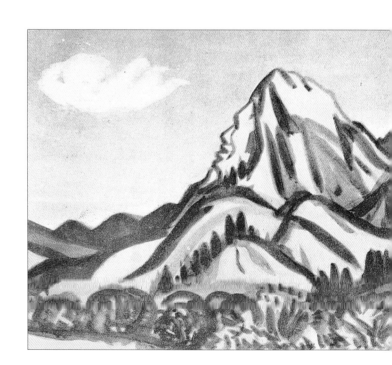

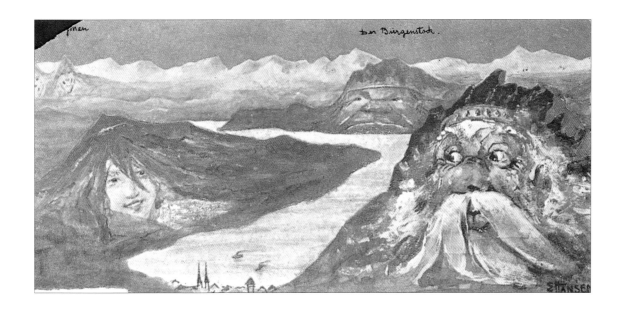

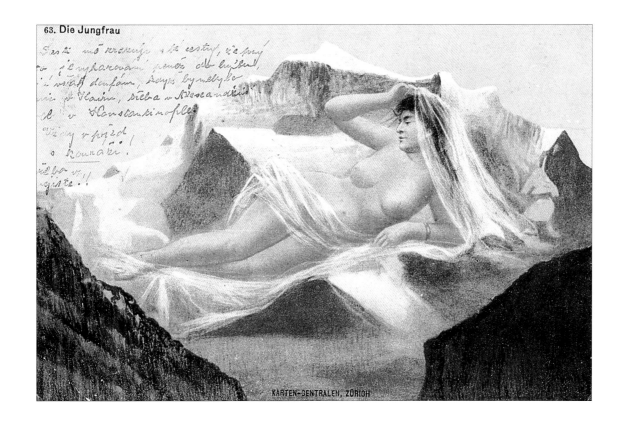

63. Die Jungfrau

KARTEN-ZENTRALEN, ZÜRICH

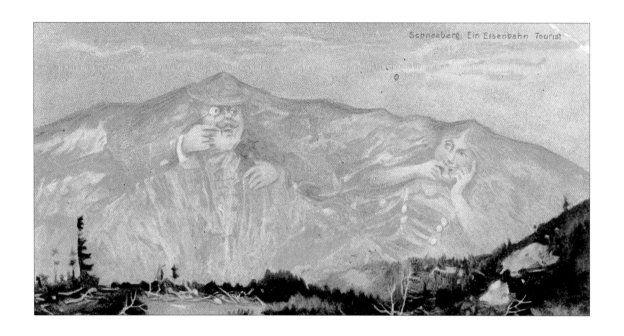

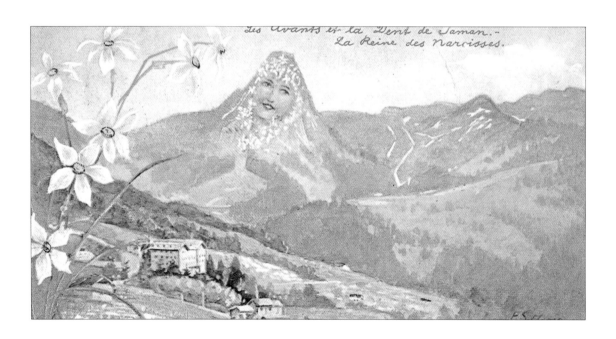

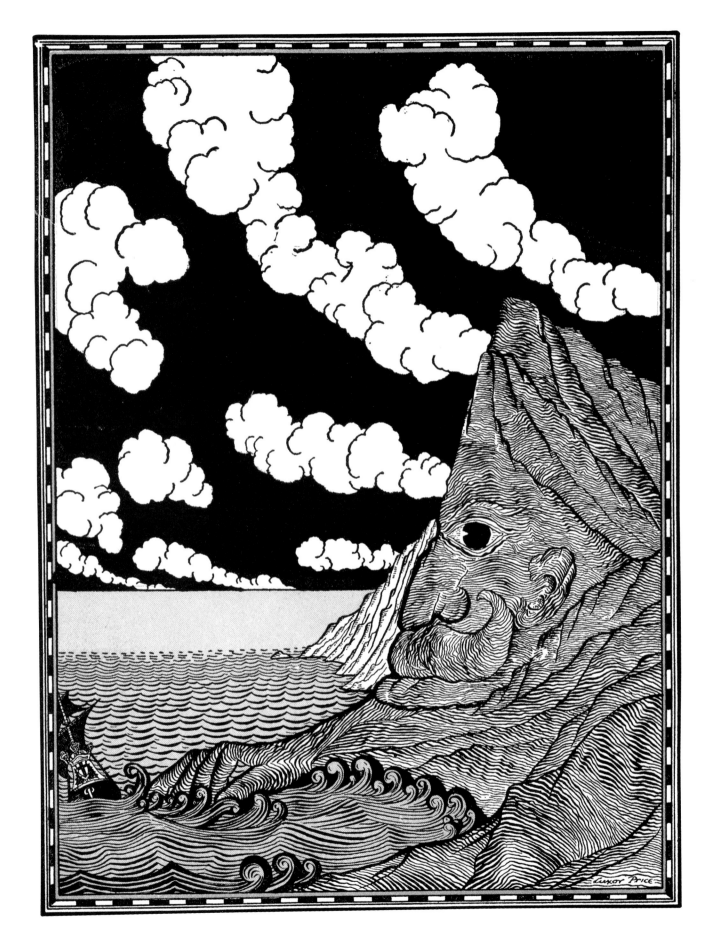

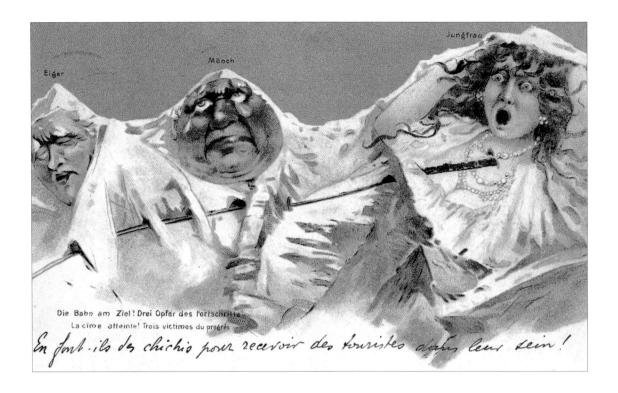

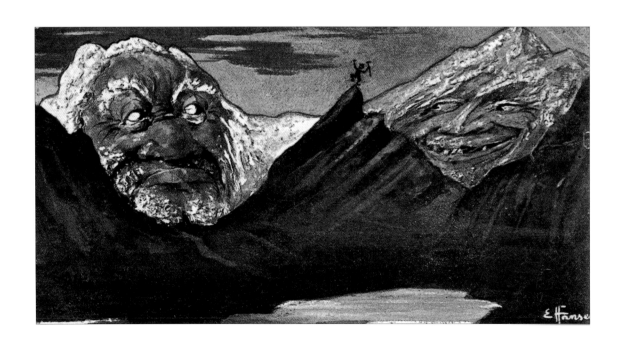

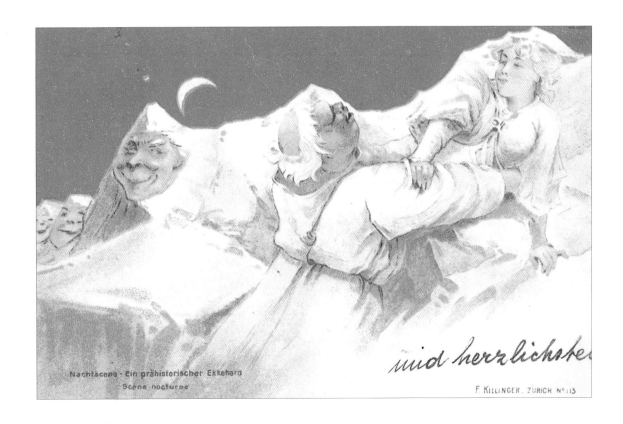

Nachtscene - Ein prähistorischer Ekkehard
Scène nocturne

F. Killinger, Zürich N° 113

Printed cards were first inserted into packages of cigarettes in the 1870's, and it was not long before they began appearing as sets on popular subjects, thus encouraging smokers to buy a given brand until the entire set was collected.

The golden age of the cigarette card was from the 1920's through the 1930's, and Britain was the richest source.

The set we reproduce here was of 50 cards, of which we reproduce 46. The subjects were many, and the art frequently of high quality. This was a set on first-aid methods.

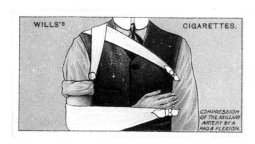

COMPRESSION OF THE AXILLARY ARTERY BY A PAD & FLEXION.

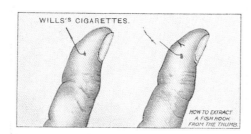

HOW TO EXTRACT A FISH HOOK FROM THE THUMB.

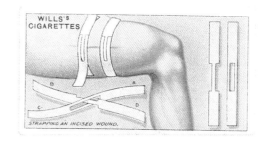

STRAPPING AN INCISED WOUND.

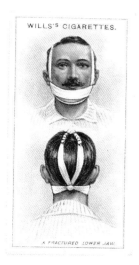

A FRACTURED LOWER JAW.

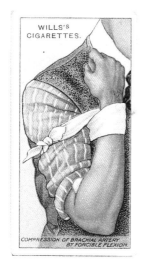

COMPRESSION OF BRACHIAL ARTERY BY FORCIBLE FLEXION.

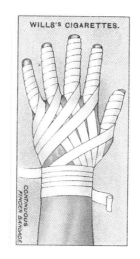

CONTINUOUS FINGER BANDAGE.

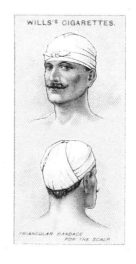

TRIANGULAR BANDAGE FOR THE SCALP.

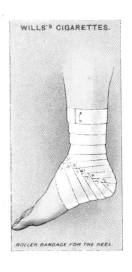

ROLLER BANDAGE FOR THE HEEL.

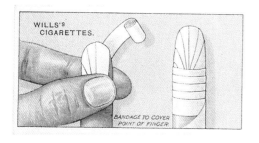

BANDAGE TO COVER POINT OF FINGER.

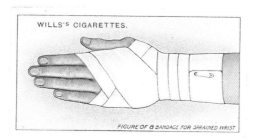

FIGURE OF 8 BANDAGE FOR SPRAINED WRIST.

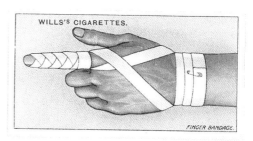

FINGER BANDAGE.

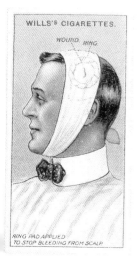

RING PAD APPLIED TO STOP BLEEDING FROM SCALP.

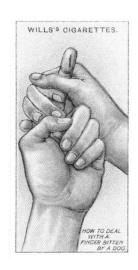

HOW TO DEAL WITH A FINGER BITTEN BY A DOG.

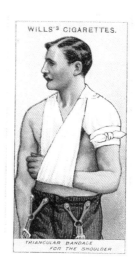

TRIANGULAR BANDAGE FOR THE SHOULDER.

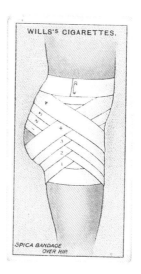

SPICA BANDAGE OVER HIP.

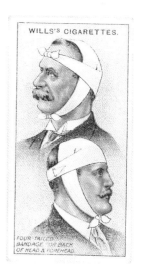

FOUR-TAILED BANDAGE FOR BACK OF HEAD & FOREHEAD.

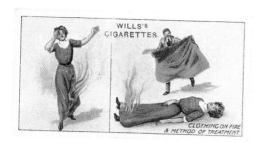

CLOTHING ON FIRE & METHOD OF TREATMENT

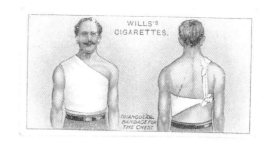

TRIANGULAR BANDAGE FOR THE CHEST

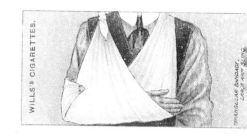

TRIANGULAR BANDAGE, LARGE ARM SLING

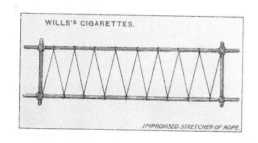

IMPROVISED STRETCHER OF ROPE

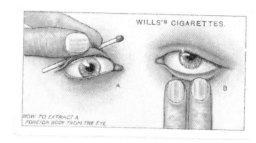

HOW TO EXTRACT A FOREIGN BODY FROM THE EYE

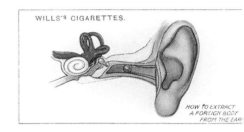

HOW TO EXTRACT A FOREIGN BODY FROM THE EAR

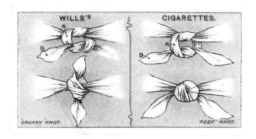

GRANNY KNOT. REEF KNOT.

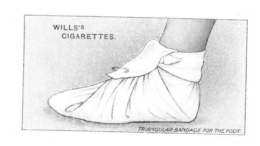

TRIANGULAR BANDAGE FOR THE FOOT.

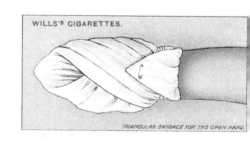

TRIANGULAR BANDAGE FOR THE OPEN HAND.

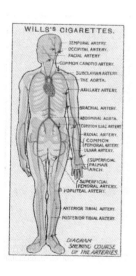

DIAGRAM SHEWING COURSE OF THE ARTERIES.

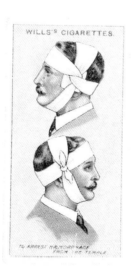

TO ARREST HAEMORRHAGE FROM THE TEMPLE.

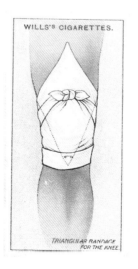

TRIANGULAR BANDAGE FOR THE KNEE.

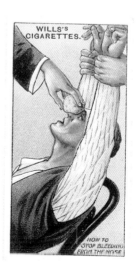

HOW TO STOP BLEEDING FROM THE NOSE.

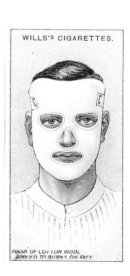

MASK OF COTTON WOOL APPLIED TO BURNS ON FACE.

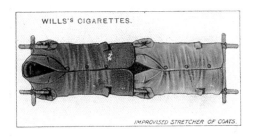

WILLS'S CIGARETTES.

IMPROVISED STRETCHER OF COATS.

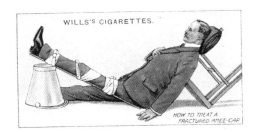

WILLS'S CIGARETTES.

HOW TO TREAT A FRACTURED KNEE-CAP.

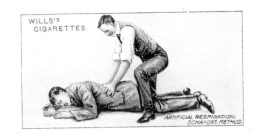

WILLS'S CIGARETTES.

ARTIFICIAL RESPIRATION: SCHÄFER'S METHOD.

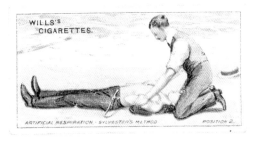

WILLS'S CIGARETTES.

ARTIFICIAL RESPIRATION - SYLVESTER'S METHOD. POSITION 2.

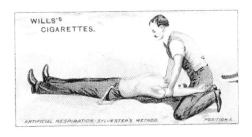

WILLS'S CIGARETTES.

ARTIFICIAL RESPIRATION - SYLVESTER'S METHOD. POSITION 1.

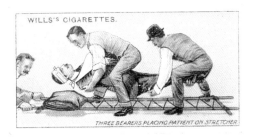

WILLS'S CIGARETTES.

THREE BEARERS PLACING PATIENT ON STRETCHER.

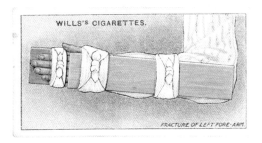

WILLS'S CIGARETTES.

FRACTURE OF LEFT FORE-ARM.

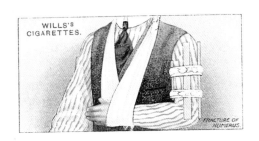

WILLS'S CIGARETTES.

FRACTURE OF HUMERUS.

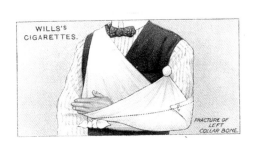

WILLS'S CIGARETTES.

FRACTURE OF LEFT COLLAR BONE.

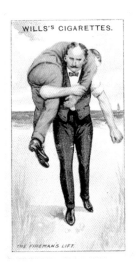

WILLS'S CIGARETTES.

THE FIREMAN'S LIFT.

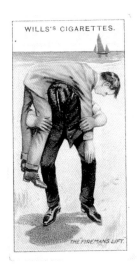

WILLS'S CIGARETTES.

THE FIREMAN'S LIFT.

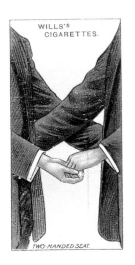

WILLS'S CIGARETTES.

TWO-HANDED SEAT.

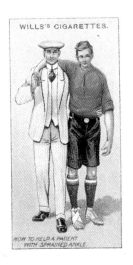

WILLS'S CIGARETTES.

HOW TO HELP A PATIENT WITH SPRAINED ANKLE.

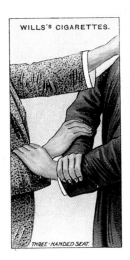

WILLS'S CIGARETTES.

THREE-HANDED SEAT.

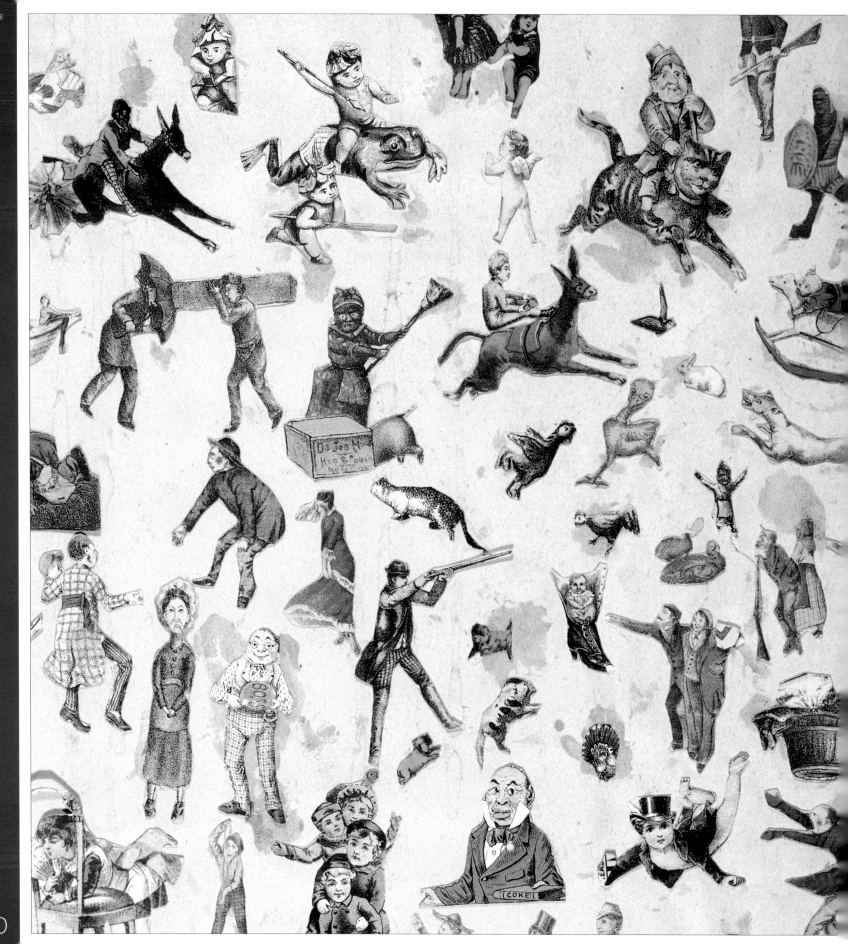

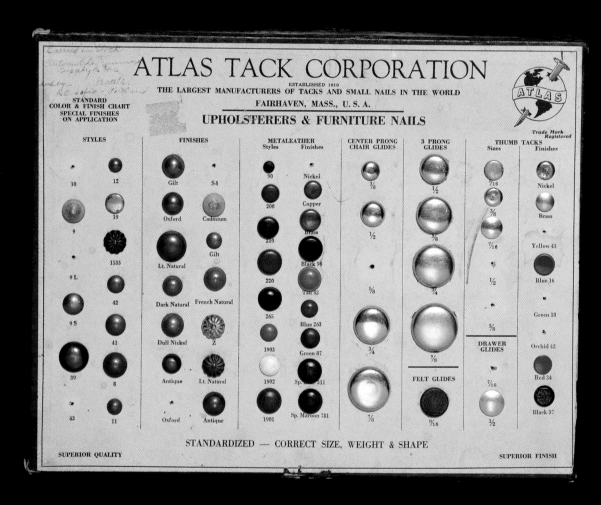

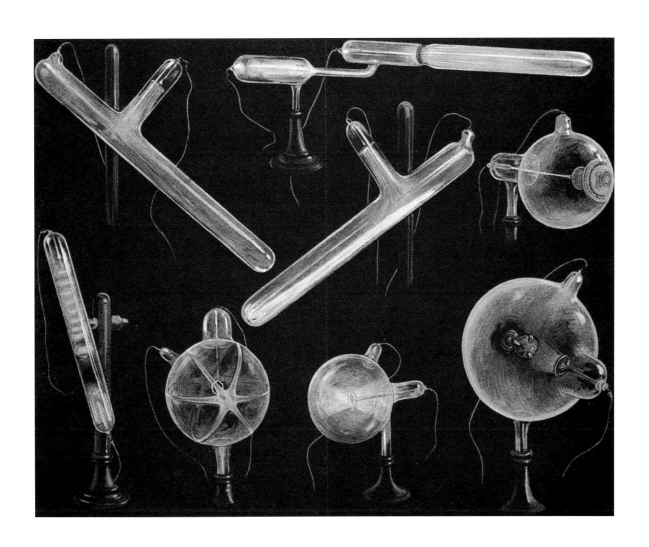

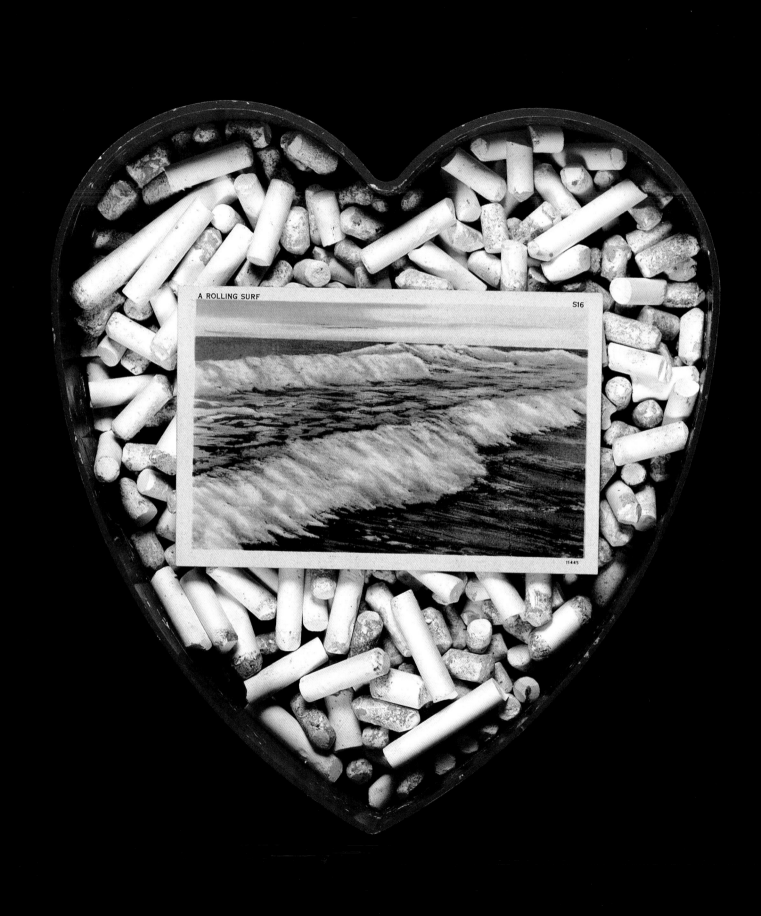

You think I'm speaking these words? When a key turns in a lock, the lock makes a little opening sound.

Rumi

No snowflake ever falls in the wrong place.

Zen

Each song is love's stillness. Each star is time's stillness, a knot of time. Each sigh is the stillness of the shriek.

Federico Garcia Lorca

Real singing is a different movement of air. Air moving around nothing.

Rainer Maria Rilke

We are asleep with compasses in our hands.

W.S. Merwin

Actually, light dazzles me. I keep only enough of it in me to look at night, the whole night, all nights.

Paul Eluard

UNEXPECTED AND INEVITABLE JUXTAPOSITIONS

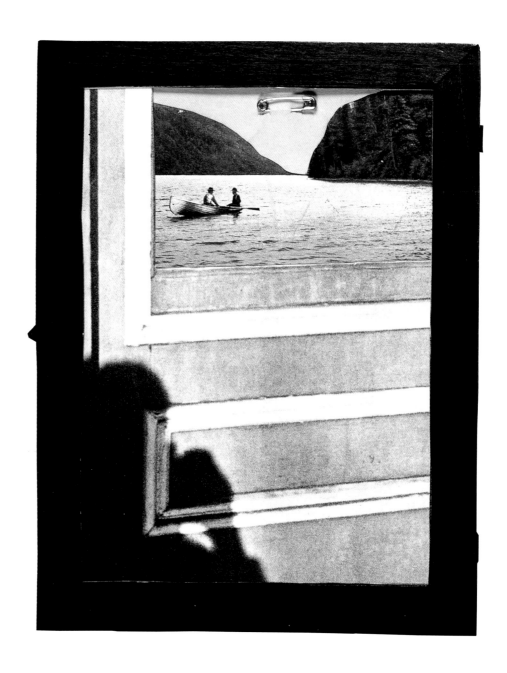

I dwell in possibility.

Emily Dickinson

It matters immensely. The slightest sound matters. The most momentary rhythm matters. You can do as you please, yet everything matters.

Wallace Stevens

Solitude, my mother, tell me my life again.

O.V. de Milosz

Don't think, but look.

Ludwig Wittgenstein

Between yea and nay, how much difference is there?

Lao Tzu

Carrying a medicine for which no one has found the disease and hoping I would make it in time.

Richard Shelton

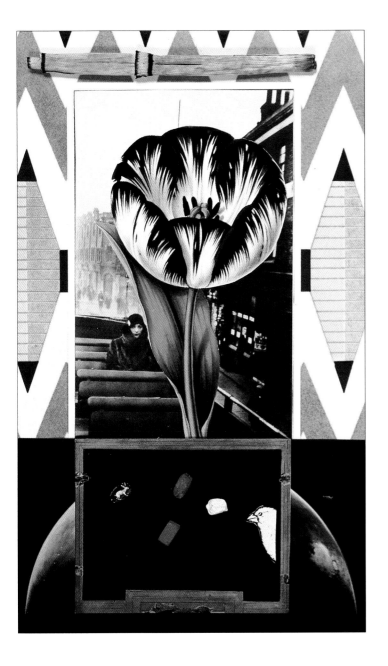

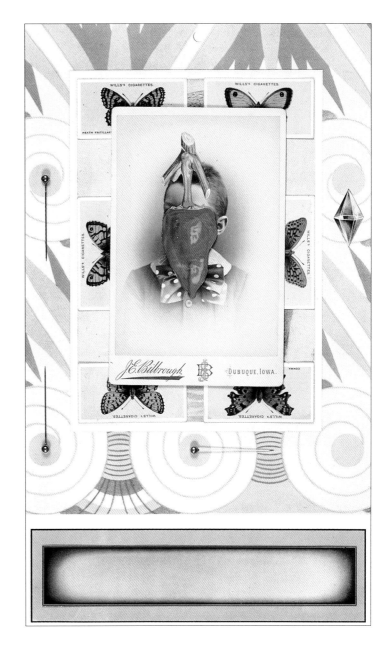

Include the knower in the known.

Julian Jaynes

Perhaps our heart is made of the answer that is never given.

René Char

If you think you're free, there's no escape possible.

Ram Dass

Everything should be as simple as it is, but not simpler.

Albert Einstein

My whole life is waiting for the questions to which I have prepared answers.

Tom Stoppard

Sit, walk, or run, but don't wobble.

Zen

UNEXPECTED AND INEVITABLE JUXTAPOSITIONS

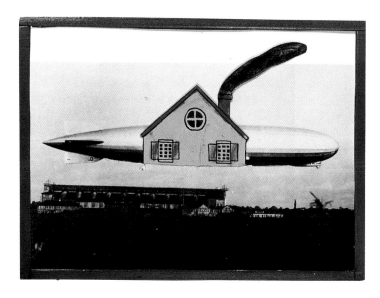

In the palm of one hand now the rain falls. From the other the grass grows. What can I tell you?

Vasko Popa

Quit this world. Quit the next world. Quit quitting.

Ram Dass

Call it a dream. It does not change anything.

Ludwig Wittgenstein

Says yes when nobody asked.

Lao Proverb

I am going to school myself so well with things that, when I try to explain my problems, I shall speak, not of self, but of geography.

Pablo Neruda

I looked down and traced my foot in the dust and thought again and said, "OK—any star."

William Stafford

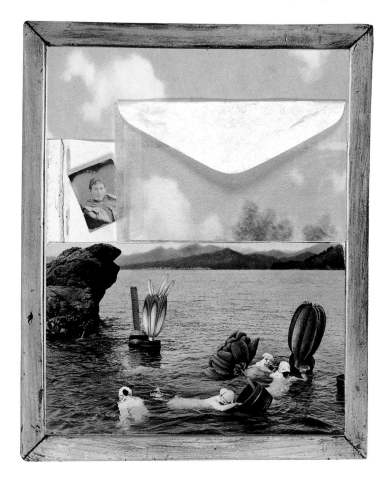

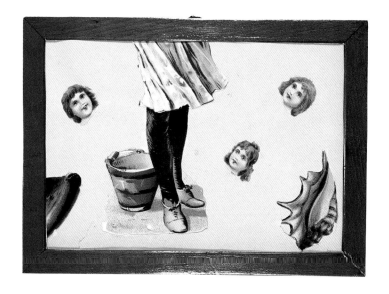

There is another world, but it is in this one.

Paul Eluard

There is no reason why a kaleidoscope should not have as much fun as a telescope.

Mark Twain

Close your hand—do you feel an absence or a presence?

Brenda Hetty

My business is Circumference.

Emily Dickinson

Thinking: freeing birds, erasing images, burying lamps.

Pablo Neruda

Between living and dreaming is the third thing. Guess it.

Author Unknown

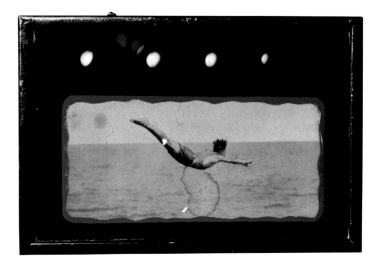

Two parallel lines meet somewhere in infinity...and they believe it.

G.C. Lichtenberg

I think we are responsible for the universe, but that doesn't mean we decide anything.

René Magritte

May my silences become more accurate.

Theodore Roethke

Absence of evidence is not evidence of absence.

Author Unknown

Consideration—a nice word meaning putting two stars together.

Buckminister Fuller

To return what exists to pure possibility; to reduce what is seen to pure visibility; that is the deep, the hidden work.

Paul Valery

I begin with what was always gone.

W.S. Merwin

There's a kind of waiting you teach us-—the art of not knowing.

William Stafford

Whether it happened so or not I do not know; but if you think about it you can see that it is true.

Black Elk

Enchantment is destroyed by vagueness, and mystery exists only in precise things.

Jean Cocteau

There is no truth. There is only perception.

Gustave Flaubert

My final belief is suffering. And I begin to believe that I do not suffer.

Antonio Porchia

Another way of approaching the thing is to consider it unnamed, unnamable.

Francis Ponge

I am homesick for a country. I have never been there. I shall never go there. But where the clouds remember me distinctly.

Hilde Domin

Wait: I have one foot already through the black mouth of the first nothing.

Juan Ramon Jimenez

There's an alternative. There's always a third way, and it's not a combination of the other two ways. It's a different way.

David Carradine

And somebody would come and knock on this air long after I have gone and there in front of me a life would open.

W.S. Merwin

That which we die for lives as wholly as that which we live for dies.

e.e. cummings

What does not exist is so handsome.

Rumi

Be patient toward all that is unsolved in your heart and try to love the questions themselves. Do not seek the answers, which cannot be given you, because you would not be able to live them. And the point is, to live everything. *Live* the questions now. Perhaps you will then gradually, without noticing it, live along some distant day into the answer.

Rainer Maria Rilke

And the end of all our exploring
Will be to arrive where we started.
And know the place for the first time.

T.S. Eliot

What is most admirable in the fantastic is that the fantastic doesn't exist; all is real.

André Breton

We burn daylight.

Shakespeare

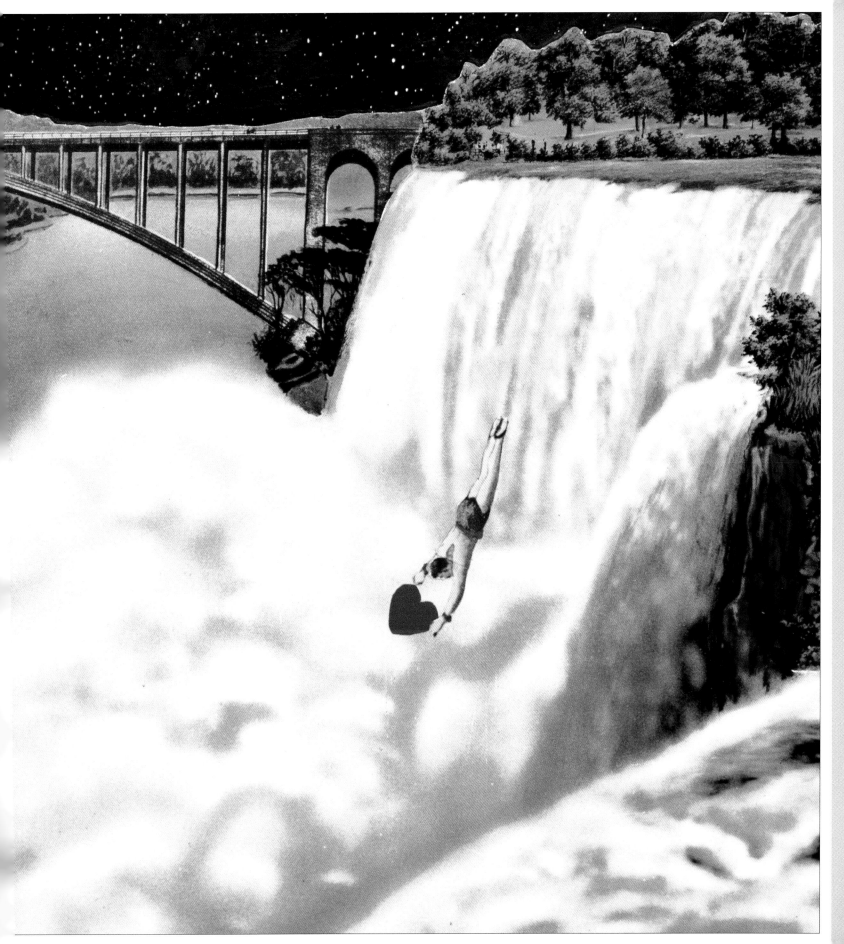

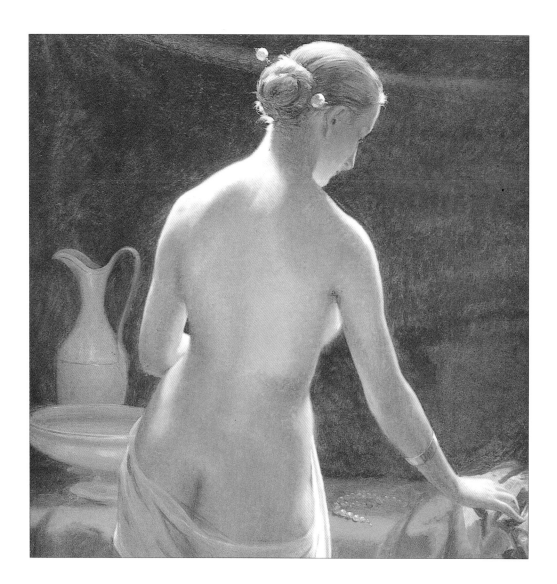

"Oof!" he said, tottering.

What his eye had rested on was the back view of a girl in some sort of beige uphol-stery, who was standing looking into a shop window, and it was a back view which seemed to speak to his very depths. Back views, of course, are not everything, and he was aware that the prudent man reserves judgment until that crucial point in the proceed-ings when the subject turns round, nevertheless he stood stunned and goggling. He had that feeling, which comes to all of us at times, that a high spot in his life had been reached and that he was about to undergo some great spiritual experience.

P.G. Wodehouse

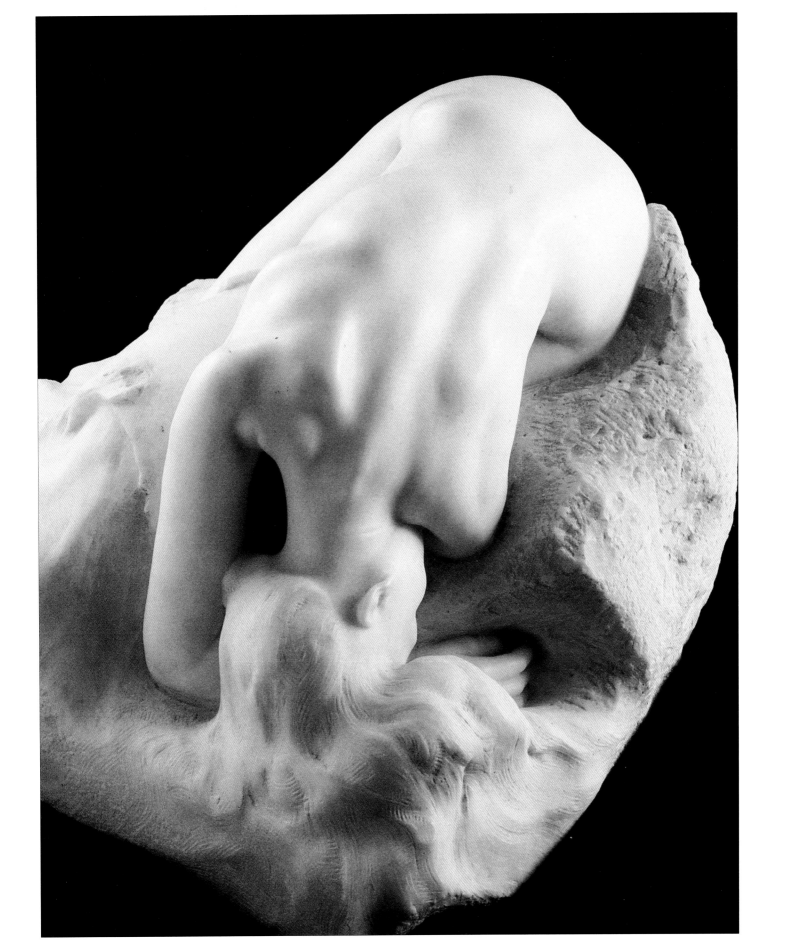

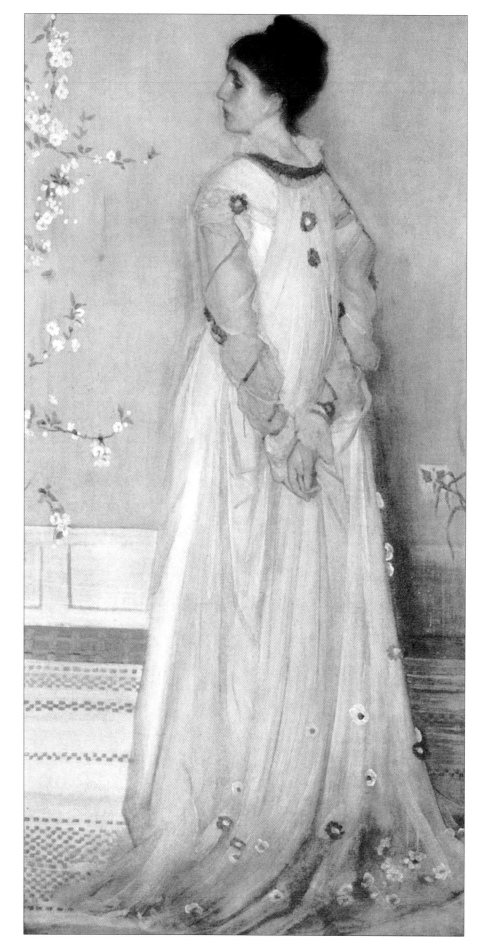

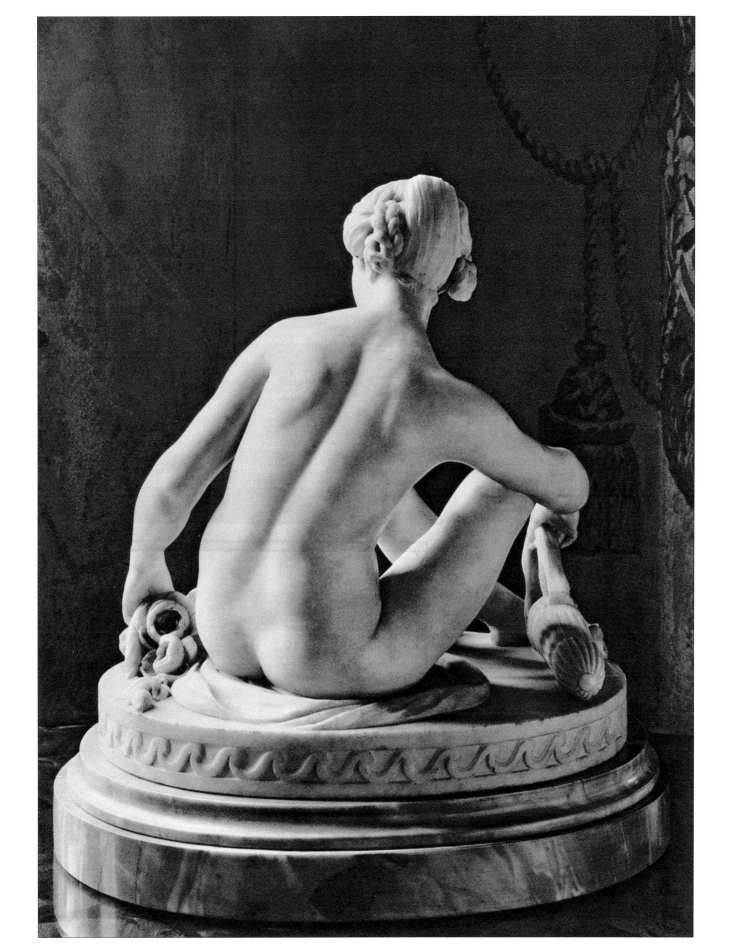

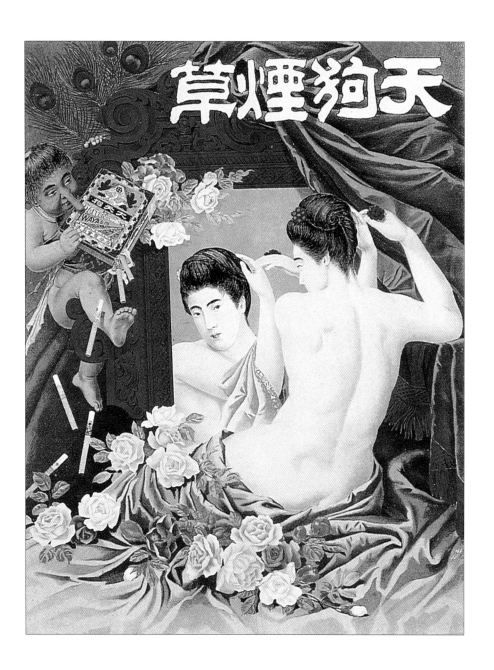

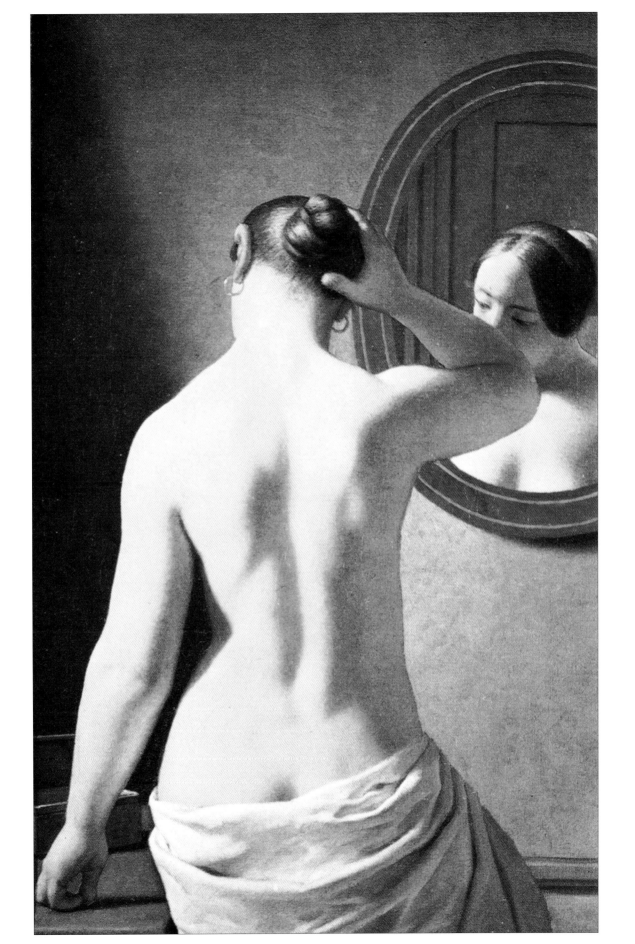

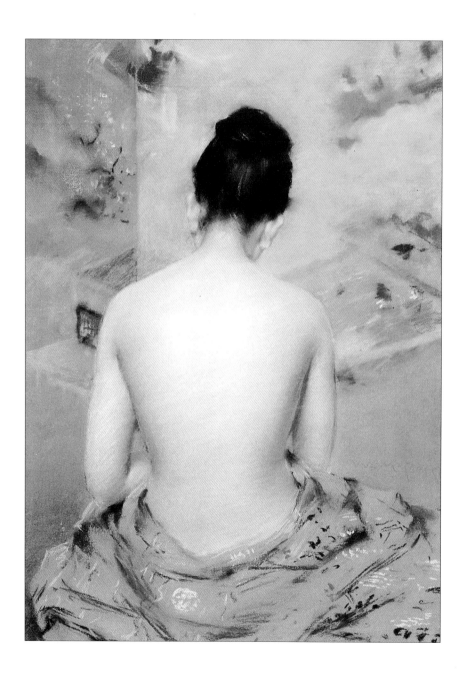

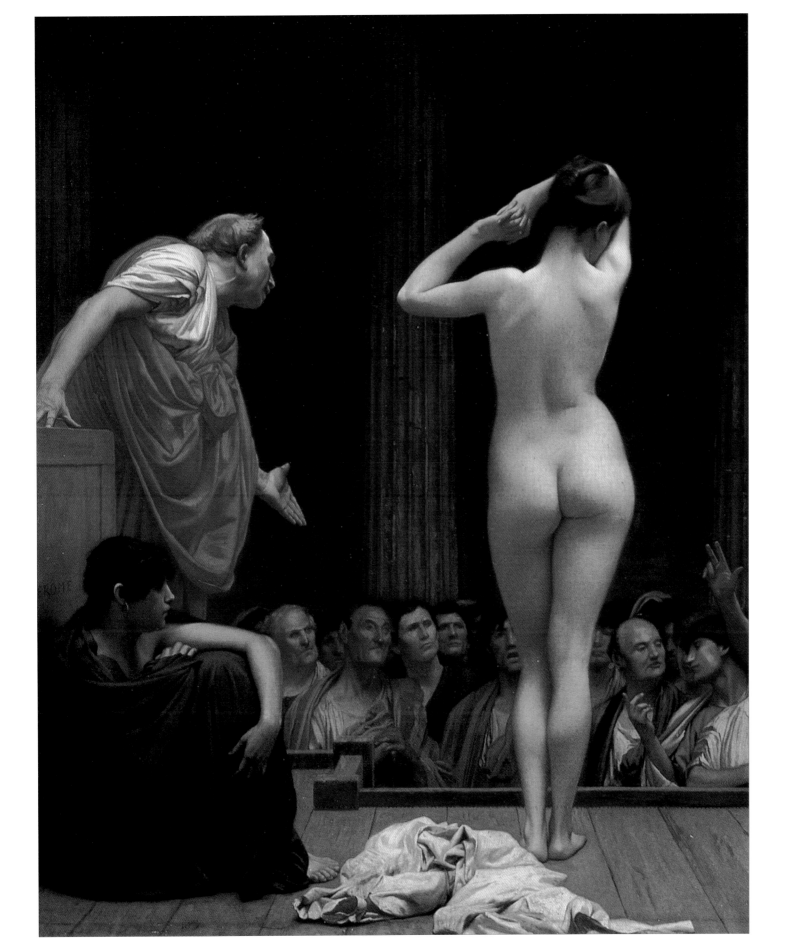

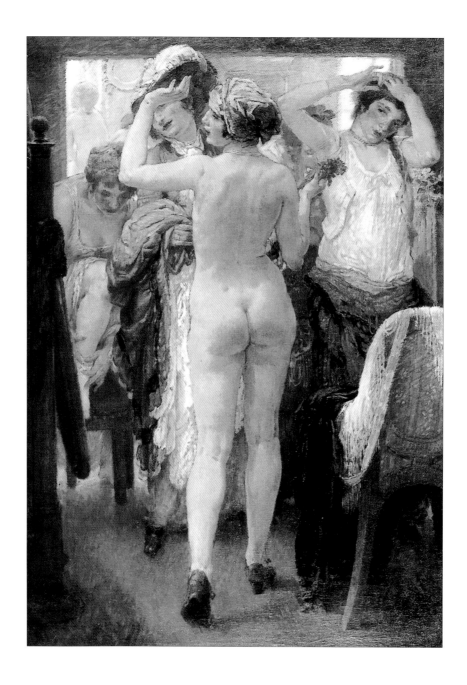

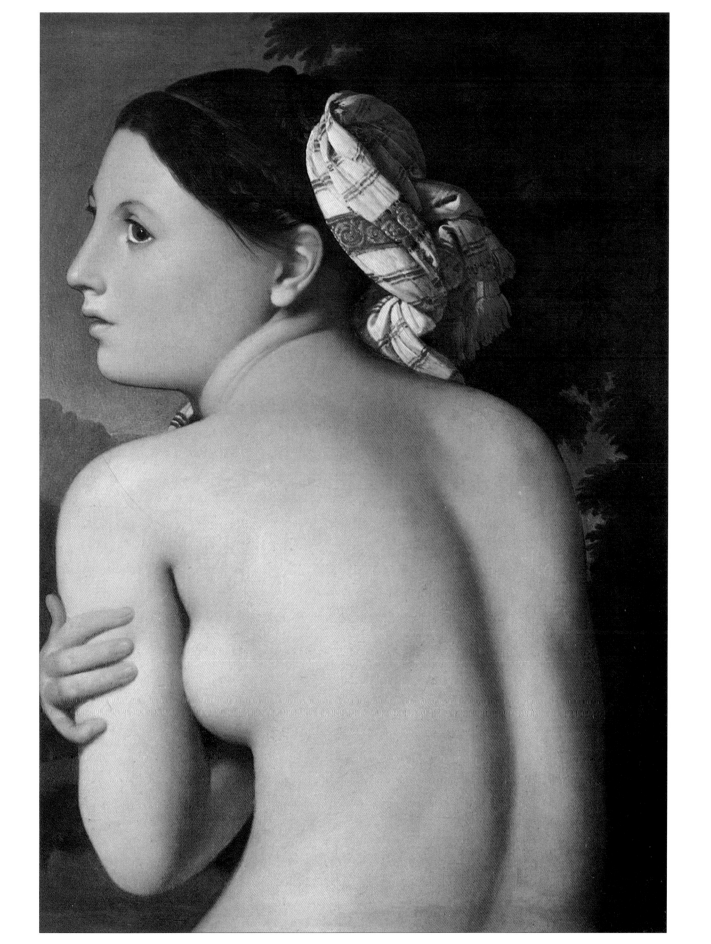

PAGE 80

Wooden dibble board. Dibble boards were used to make a large number of holes in the ground for planting seeds. The board shown here makes 150 holes each time it is pressed into the soil. Connecticut c. 1880-1900.

PAGE 81

A patent model for a corpse preserver patented by J.J. Reicherts in 1868. It had double walls filled with charcoal to slow the melting of the ice.

PAGE 82

Assembled in 1950 from a toy erector set, this box is a section of a heart pump and forerunner the heart lung machines used in open-heart surgery today. It was built by William Sewall, Jr., who used it successfully in experimental surgery on dogs.

PAGE 83

A photograph by Frank and Lillian Gilbreth made as part of a study on the movements of workers. The worker wore a ring that flashed as she moved, allowing analysis.

PAGE 84

top. Piece of an outdoor sculpture waiting for assembly. Mexico, 1971.
Designs for ice cream cones made for a patent application by:
 bottom-left. BW Devereux in 1939
 bottom-right. William Houston in 1940.

PAGE 85

A rayogram (or cameraless photograph) made by Man Ray in 1922. It shows the model Kiki raising a wineglass and an egg.

PAGE 86

Emperor Napoleon III presented Queen Victoria with a brass field gun in 1853, complete with ammunition, which is illustrated here. The shot, wad and charge made up a complete cartridge weighing 12 pounds.

PAGE 87

View of the Rasi Valaya Yantra, or ecliptic instrument, a dramatic grouping of twelve giant dials, one for each sign of the zodiac, for determining the sun's latitude and longitude. They were conceived and erected in the 18th century by the Maharajah Jai Singh II, in Jaipur, India. Photographs by Isamu Noguchi.

Picture Credits

Copyright L.J. Bridgman. *from* Guess, 1901.

8 The Exhibit Supply Company. "The Pinochle Girl," 1928.

9 Top: Photograph (Muslim Yashmak). / Bottom: Photograph (John Sumerhayes, safe-cracker).

10 Hagenbeck-Wallace Circus. Poster, 1929.

11 Left: Schall. Photograph (Corset by Diana Slip), 1929. / Right: Henry Buehman. Photograph (Peanut Vendor), circa 1890.

12 Laure Guillot. Photograph (Strapless bra), circa 1930s.

13 Photograph (New Hebrides, penis sheaths).

14 Snap Wyatt. Sideshow banner, circa 1940s.

15 Edwin S. Curtis. Photograph, circa 1905.

17 Martin Gusinde. Photograph (Fuegians).

18 Painting and Drawing Book.

19 Left: Space Happy, 1953. / Right: Cowboys and Indians..

20 Top: Gertie the Goat Story and Drawing Book, 1940. / Bottom: Little Jack Rabbit Coloring Book, 1926.

21 Young Artist's Painting and Drawing Book, circa 1890.

22 Top: Merry Times Painting Book, 1907. / Bottom: Road and Rail.

23 Ball Paint Book, 1911.

24 Top left: Paint Book, 1949. / Top right: My Party Paint Book, 1941.

25 Top: Roy Rogers Coloring Book. / Bottom: Travel Bag Coloring Book, 1938.

27 Top: circa 1890s.

28 Top right: 1925. / Bottom: 1932.

29 1957.

30 Bottom left: 1932. / Right: 1932.

31 Top left: 1926. / Right: circa 1900. / Bottom left: circa 1890s.

42 Top: Magazine illustration, 1923. / Bottom: Calendar, circa 1920s.

43 Magazine cover, 1913.

44 McClelland Barclay. Magazine cover, 1929.

45 Top left: Trade card, circa 1890s. / Top right: Lester Ralph. Magazine cover, 1915.
Bottom: Maurice Letoir. French advertisement, 1900.

46 Top left: Frank Leyendecker. 1917. / Top right: Italian postcard. / Bottom: Scrap, 1890.

47 Magazine cover, 1904.

50 Richard Kehl. Collage.

59 Top left: Indian cotton label. / Bottom left: Rya Burley. *from* Three Little Kittens , 1939.
Right: Edith Hayllar. "A Summer Shower," 1883.

60 Right: Catalog cover. / Bottom: Orange crate label.

61 Top left: Christmas card. / Top right: Indian cotton label. / Bottom: *from* Stories in Pictures, 1953.

77 Gustave Courbet. "The Hammock," 1844.

78 Edward Killingworth Johnson. "The Hammock."

79 Sir John Everett Millais. "Young Girl in White Satin Dress."

88 The Reeses. Magazine illustration, 1915.

89 Top: Magazine cartoon, 1925. / Bottom: Ruth Cobb. *from* Blackies Little Ones' Annual.

90 Magazine cartoon, 1913.

91 Top and bottom left: Dorothy Morgan. *from* Numberland, 1928. / Top right: E.G. Lutz. *from* Drawing Made Easy, 1922.
Bottom right: Currier and Ives print, 1875.

This book is typeset in Futura.

Book and cover design by Blue Lantern Studio in Seattle, Washington.

Printed and bound in Singapore by Star Standard.